NORTHERN KENTUCKY

BLACK AMERICA SERIES

NORTHERN
KENTUCKY

Dr. Eric Jackson

ARCADIA
PUBLISHING

Published by Arcadia Publishing
Charleston, South Carolina

Printed in the United States of America

Library of Congress Catalog Card Number: 2004114439

For all general information contact Arcadia Publishing at:
Telephone 843-853-2070
Fax 843-853-0044
E-mail sales@arcadiapublishing.com
For customer service and orders:
Toll-Free 1-888-313-2665

Visit us on the Internet at www.arcadiapublishing.com

CONTENTS

ACKNOWLEDGMENTS

I could not have completed this project without much encouragement and unlimited assistance of numerous people. I am extremely indebted and give much thanks to my editor, Lauren Bobier. Indeed, her patience, understanding, and great vision inspired me to continue in this process despite its numerous trials and tribulations. There is no question that without her, this volume would not have been published with such precision and power.

There are many other people and institutions I wish to thank for their help and indispensable contributions to the research and compilation of this book. I will always be grateful to Jennifer Gregory, Cynthia Valletta, and their cohorts at the Frank W. Steely Library at Northern Kentucky University, as well as David E. Schroeder, the local history librarian at the Kenton County Public Library of Covington, Kentucky. Many of the photographs and other resources obtained from these individuals and their facilities played a very crucial role in the development and completion of this volume. Also, I would like to thank the various members of the Northern Kentucky African American Heritage Task Force (NKAAHTF) and the Boone County Historical Society, as well as Kathy Boemker, administrative assistant, Behringer-Crawford Museum of Covington, Kentucky. Much of the groundwork for this project would not have been accomplished without your valuable contributions. Special thanks also must go to Northern Kentucky University, particularly the Department of History and Geography, and especially to Dr. Jeffrey Williams for his professional and financial support of this project.

The preparation and writing time needed to finish this volume was far beyond what I imagined. Thus, I will be forever thankful to the following people for welcoming me into their homes, their trust in me to maintain good care of their personal photographs, and their very detailed answers to my numerous questions: Mary Northington, Hensley B. Jemmott, Virginia Bennett, Joyce Ravenscraft, Vanetta Margison, Ted Harris, Patricia Sanders, and Donna Watts.

Obviously, it is impossible to thank all the individuals whose personal strength, support, and sacrifice helped me produce this volume. However, the most important people in this area are my wife, BJ, and our children, Jennifer and Ricky. Much love and thanks goes to you all. Last, but not least, this volume is dedicated to the memories of all those people who have made the history of African Americans so rich, vital, and everlasting.

INTRODUCTION

Along the southern banks of the Ohio River, the African-American communities of Boone, Campbell, and Kenton Counties have provided an enormous amount of workers, civic and religious leaders, entrepreneurs, and activists who aided in the economic growth of this region since its inception. In addition, the presence of African-American Northern Kentuckians was critical to the emergence of a wide range of civil rights issues, especially in the area of public education. In the early 1870s, for example, a small but potent group of African-American church members helped to pave the way for the opening of Lincoln Grant School in Covington, Kentucky. However, this subject has received scant attention by most scholars of various fields and disciplines.

Indeed, African-American life in this part of the Bluegrass State has been transformed greatly over the last half-century. This viewpoint was brought to my attention during the research for this volume, in the fall of 2004, by Mary Northington and Hensley Jemmott, co-founders of the Northern Kentucky African American Heritage Task Force (NKAAHTF), who shared their thoughts with me about the history of black Americans in Northern Kentucky. Both individuals contended that, despite the current state of affairs and atmosphere of African-American life in Northern Kentucky today, "when you start to talk to the right people, the richness, power, and legacy of the past struggle and accomplishments will come alive." In one respect, this volume is dedicated to these visionaries.

As a result of the sparse amount of secondary sources available on African-American life in Northern Kentucky, this book seeks to illuminate through photographs, images of narratives, letters, and various other resources that capture the variety of obstacles black Americans faced and overcame in this part of the Bluegrass State from the enslavement period to the 1980s. To achieve this goal, this volume highlights the triumphs and tragedies, as well as the interracial diversity and segregation (both voluntary and involuntary) that permeated the African-American experience in the region for decades. Also crucial, within these pages not only are black American institutions highlighted, but civic organizations, individuals, businesses, churches, schools, and clubs are shown from a variety of perspectives, as well.

On another level, the multitude of images contained in this book demonstrate to all readers that enslavement, segregation, racial prejudice, and outright racism did exist, in all shapes and forms, throughout Northern Kentucky. Despite this situation, however, local African-American residents built and preserved their communities, which enhanced their livelihood and installed an enormous sense of hope, pride, and interconnectedness. I believe that this inspirational story is most powerfully and effectively shown through the use of images and photos.

All in all, throughout the history of African-American life in Northern Kentucky, despite some insurmountable odds, numerous African Americans were able to achieve heights that their counterparts in other parts of the state, particularly in the more urban centers or southern regions, could only dream about on a daily, weekly, monthly, or yearly basis. Most importantly, one cannot question that these individuals made significant contributions to many fields, ranging from music, medicine, and literature to performing arts, poetry, education, and athletics. Such achievements deserve more attention from all Northern Kentuckians of all walks of life.

One

IMAGES OF THE ENSLAVEMENT PERIOD

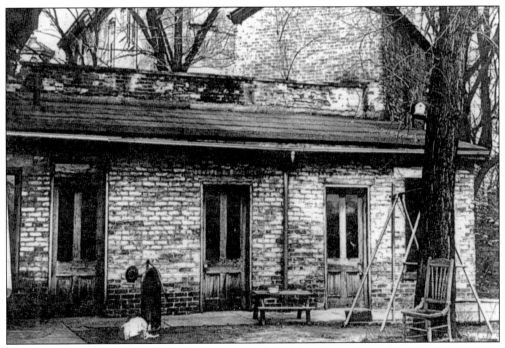

SLAVE QUARTERS. Located along the Ohio and Licking Rivers and known as Northern Kentucky's largest city, Covington was founded in 1815. Its early history, both culturally and economically, often echoed Cincinnati, Ohio. During these years, most African Americans who resided in the city were enslaved people of color who lived in slave quarters built behind their owners' homes. Pictured here is one such dwelling on the property known as the Carneal House. (Courtesy of the Kenton County Public Library.)

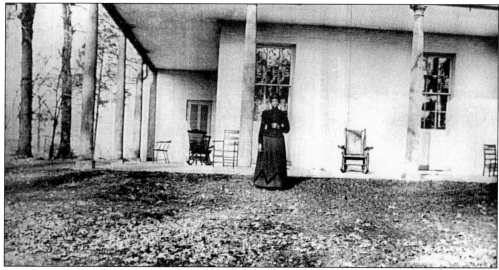

AN ENSLAVED AFRICAN AMERICAN ON THE WALLACE FAMILY PROPERTY. During the antebellum period, the ownership of enslaved persons of color was quite profitable throughout Kentucky, with approximately 80,000 individuals being shipped throughout the state via the slave trade from 1830 to 1860. Obviously, slavery did function as a valuable labor and economic source in the northern part of the state. This photograph, showing an enslaved woman female named Rachel, is one such example. (Courtesy of the Kenton County Public Library.)

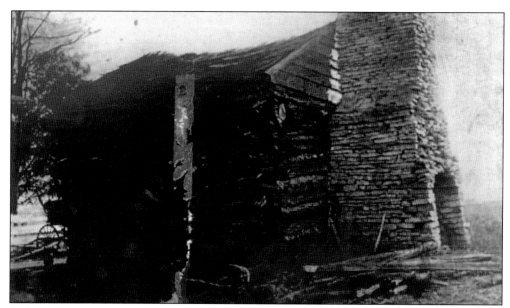

A SLAVE CABIN. Boone County, named after the pioneer Daniel Boone and bordered by Gallatin, Grant, and Kenton Counties, was established in December of 1798. Compared to slavery in many cities throughout the state, rural enslavement forced African Americans to deal with a different set of living conditions. This Boone County slave cabin would have probably housed three or four people. (Courtesy of the Frank Steely W. Steely Library, Special Collections, Northern Kentucky University.)

An Unidentified African-American Enslaved Couple. Because of the nature of enslavement in Kentucky, the contact between slaves and owners was slightly closer compared to what usually occurred on large plantations throughout the Deep South. Nevertheless, clothes were still issued mostly on an annual or semiannual basis. The two unidentified people pictured here illustrate that on occasion this situation was altered, and sometimes semiformal attire was awarded. (Courtesy of the Kenton County Public Library.)

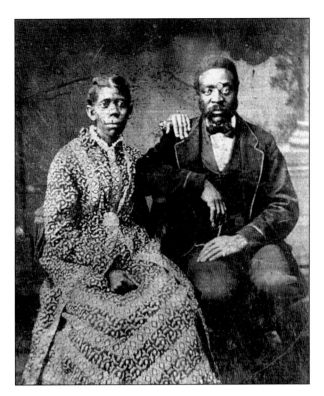

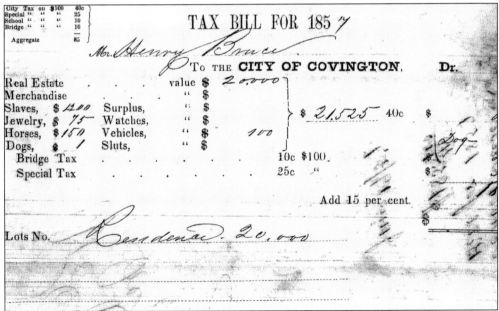

A Tax Bill. The profits generated from owning a person of color had some shortcomings. One of the major problems was that because slaves were viewed by most whites (and the law) as property, taxes had to be paid. Pictured here is a tax bill issued by the City of Covington to Henry Bruce, a prominent local entrepreneur. (Courtesy of the Frank W. Steely Library, Special Collections, Northern Kentucky University.)

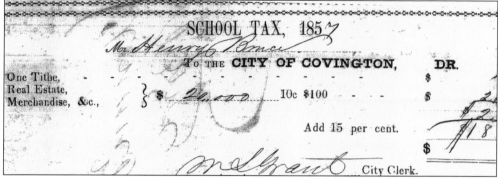

A TAX BILL, 1857. Occasionally taxes generated from the institution of enslavement aided various community institutions and organizations in the northern part of the state. The tax bill pictured here shows that some of the money made by Henry Bruce was used to support the public school system of Covington, Kentucky. (Courtesy of the Frank W. Steely Library, Northern Kentucky University.)

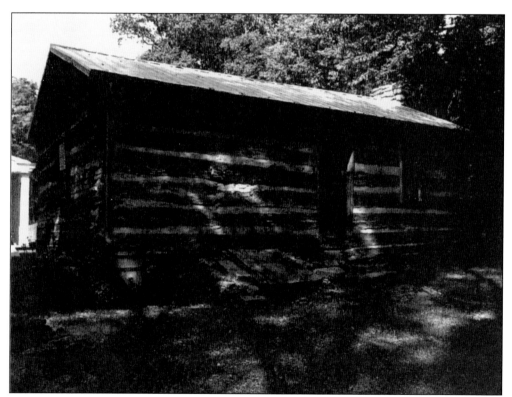

THE DINSMORE HOMESTEAD—BOONE COUNTY. James Dinsmore in 1839 purchased several hundred acres of land in Boone County, Kentucky, for himself and his family. He eventually purchased a number of enslaved black Americans to help maintain the home, land, and family itself. Pictured here is the detached kitchen that African-American captives used to cook the family meals for the Dinsmores. (Courtesy of the Institute of Freedom Studies, Northern Kentucky University.)

AN AFRICAN-AMERICAN CEMETERY RECORD. Based on *de jure* or *de facto* laws, most enslaved African Americans who died were buried in segregated cemeteries from the Colonial period to the 1970s. Kentucky was no exception. This image illustrates the care and detail that went into the development of such a cemetery in Northern Kentucky. (Courtesy of the Frank W. Steely Library, Special Collections, Northern Kentucky University.)

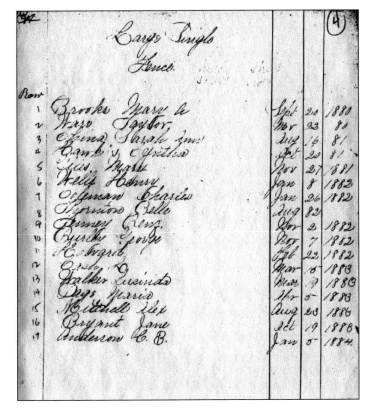

A LIST OF ENSLAVED AFRICAN AMERICANS. Although most Northern Kentuckians did not own enslaved African Americans, those who did took great care to maximize their profit margin. Thus, many owners listed their captives by name and age in various governmental records and ledger books. (Courtesy of the Frank W. Steely Library, Special Collections, Northern Kentucky University.)

13

CHARLES MCMICKEN'S LETTER OF OWNERSHIP AND EMANCIPATION (CAMPBELL COUNTY). Occasionally, African-American captives obtained their freedom from bondage. In Northern Kentucky, this situation usually occurred via the Underground Railroad. However, some owners willingly manumitted their captives. Charles McMicken does this in a letter written in 1819 when he notes the emancipation of a female enslaved African American named Adaline Richardson. (Courtesy of the Frank W. Steely Library, Special Collections, Northern Kentucky University.)

A LETTER, 1858. The nature of enslavement in Northern Kentucky sometimes reached people outside of the United States. Here is an 1858 letter Henry Bruce Jr. received from E.R. Philips that recounts the travels of former enslaved persons from Kentucky to Canada. (Courtesy of the Frank W. Steely Library, Special Collections, Northern Kentucky University.)

14

LAND AND PROPERTY TRANSACTION. The view that enslaved persons of color were nothing more than property is shown clearly on this 1825 memorandum of sales. It was drafted by William Routt, a prominent lawyer from Campbell County, for the transfer of a large area of land, along with an African-American captive, to a local Boone County resident. (Courtesy of the Boone County Historical Society.)

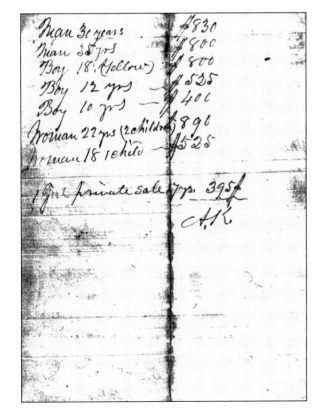

AN 1862 LETTER. The enormous profits associated with owning enslaved African Americans is displayed quite clearly through a legal document that lists the gender, age, and value of each captive. (Courtesy of the Frank W. Steely Library, Special Collections, Northern Kentucky University.)

A Letter, 1862. Even in Northern Kentucky, the system of slavery had a profound impact on the stances individuals took during the Civil War. This 1862 letter reveals the fact that despite the intense nature of the Civil War, the issue of enslavement was still present. (Courtesy of the Frank W. Steely Library, Special Collections, Northern Kentucky University.)

Letty's Conversion
John Taylor's Slave

Letty was a slave church member at Bullitsburg Baptist Church, Boone County, Kentucky, whom we know more about than any other, thanks to John Taylor's description.

Letty (sometimes Lettice) was a slave of John Taylor's, who made a profession faith before the church on August 24, 1800, three weeks after her brother, Asa, became a member. Taylor expresses himself as others of that time who were involved in the slave business,

"lest I should be considered partial to those of higher rank, we will state the conversion of this poor black woman; I had owned Letty as my property, from a child, and she was now the mother of children."

Her conversion apparently affected him greatly as he used nearly three pages of his history to describe how God worked in her behalf to save her. Taylor says more about her than anyone else he refers to in his entire book. He says:

A Conversation with John Taylor's Slave, Boone County. During the antebellum period, the complex and contradictory nature of slavery and religion greatly intensified throughout the United States. Northern Kentucky was no exception. This narrative displays the nexus quite magnificently with the story of an enslaved African-American female named Letty, John Taylor's slave, who was a member of the Bullitsburg Baptist Church of Boone County. (Courtesy of the Boone County Historical Society.)

Purchase of a Slave Girl named Sharlot. 1811

Know all men by these presents that I Baylis Cloud of the County of Boone and State of Kentucky for divers good causes but especially for and in consideration of the sum of one hundred and sixty dollars do hearby bargain sell and deliver a certain negro girl named Sharlot the girl supposed to be aged five year and six months old unto Robert Kirtley of said County of Boone which a side negroe girl I do hearby warrant and defend the title unto the said Robert Kirtley and his heirs for ever against the claim or claim of all Persons whatever in witness whearof I have heareunto set my hand affixed my seal this 8th day of March 1811

Baylis Cloud (seal)
Signed Sealed & Delivered
in preasence of
Test
Absalom Graves

A Purchase Document of a Slave Named Sharlot, 1811. Those individuals who had the resources and a need for an enslaved person of color had no problem obtaining one. This 1811 purchase sheet of an enslaved girl named Sharlot notes the value and age of the enslaved person. (Courtesy of the Boone County Historical Society.)

A Slave Transaction: Eliza, 13 Feb 1825

Note: William Routt was a lawyer from Campbell County. This sale was became part of a larger land transaction recorded in Boone County Deed Book M, page 101. In return for the black girl Eliza Maj. Scott sold Benjamin the land in Union Kentucky that he had bought at a Sheriff's sale.

Received 8th. Feby. 1827. of Jacob Fowler a receipt signed by William Routt as follows: Received 13th. February 1825. of Chasteen Scott by the hands of Benjamin D. Fowler a negro Girl Eliza at the price of Six hundred dollars in Commonwealth paper which is to be credited on account of the land purchased b Chasteen Scott & transferred to me which I am to transfer to said Benjamin D. Fowler agreeable to transfer the ballance (sic) of the Six hundred dollars after deducting the amount due me from said Scott to be applied to the credit of Jacob Fowler on accounty of services rendered to him, in my profession as a lawyer.

Wm. Routt

A Slave Transaction of Eliza, 1825. The monetary value of enslaved people of color is displayed here with the purchase of a slave named Eliza by Chasteen Scott, a local Boone County resident. (Courtesy of the Boone County Historical Society.)

Asa: The First African American Preacher
in Boone County, Kentucky

Asa, a slave originally belonging to John Taylor, made a profession of faith on August 3, 1800. Taylor tells of the revival that began in August of that year: "...we had baptized twenty, and but few young people among them, and only one man of colour. A young fellow who I had raised myself, by the name of Asa, I had learned him to read very well - he afterwards became a preacher." Taylor says Asa's conversion experience "was very striking." He was baptized with Christopher Wilson, who later became pastor at Forks of Gunpowder Baptist Church. Asa often traveled with Wilson on preaching engagements. He became a good preacher. His greatest usefulness was among his fellow blacks. Asa was the brother of Letty, whose salvation experience Taylor describes in great detail in his book (pp. 109-112).

THE FIRST AFRICAN-AMERICAN PREACHER IN BOONE COUNTY. Resistance to enslavement in Northern Kentucky took many forms. One of the most important avenues was the use of religion. This narrative describes the first black American preacher in Boone County, who was named Asa. (Courtesy of the Boone County Historical Society.)

Stampede of Slaves. — Arrest of the Fugitives.

Covington Journal

Saturday 17 June 1854
p. 2, col. 3

On Sunday night nine slaves escaped form their owners in Boone county. They were, Lewis, about 24 years of age; Susan, 39 years of age; Wesley, 6 years of age; John, 7 years of age; Almeda, 26 years of age, and Sarah Jane, 3 years of age; belonging to Mr. Wm. Walton. Shadrach, 60 years of age, to Mr. Jonas Christler; Anderson, to Mr. John P. Scott; and Lee, to the heirs of Wm. H. Blankenbeker. They crossed the river in a skiff and landed in Indiana, the proceeded to within five miles of Cincinnati, where they concealed themselves, awaiting to go to Canada. Information of their whereabouts reaching the owners, pursuit was made, and with the assistance of deputy marshals Lee Worley, of Cincinnati, and deputy sheriff Ward, of Covington, all were arrested Wednesday night. On Thursday they were taken before JOHN S. PENDERY, U. S. Commissioner, at his office in Court street, where the investigation is now going on. Messrs. KETCHUM and PUGH, of Cincinnati, and DUDLEY, of Covington, are attorneys for the claimants, and Messrs. GITCHELL and JOLIFFE for the negroes. There seems to be no doubt that the fugitives will be returned to their owners. The *Columbian* says:

'The general impression is, that the whole party will be returned to their alleged owners. It is reported that twenty-seven slaves in all escaped from Grant and Boone counties, Ky., on last Sunday, but no trace has been discovered of eighteen of them. There is no excitement in relation to the return of those caught, as the owners seem

SLAVE RESISTANCE. Enslaved African Americans who ran away to acquire freedom were a major concern of both owners and community leaders alike. No expense would be spared to recapture this fugitive. Described in the June 17, 1853 edition of the *Covington Journal* are routes a captive used to abscond as well as how the pursuit included "deputy marshals Lee Worley, of Cincinnati, and deputy sheriff Ward of Covington." (Courtesy of the Boone County Historical Society.)

The Story of Henrietta Woods of Boone County, and the Son of the Landlord from Florence

Covington Journal 8 Apr 1876 p. 2, col. 6

> The Cincinnati Commercial of Sunday last tells a long story of Henrietta Woods (col.) She was first of Boone county, then sold to Louisville and afterwards her mistress moved to Cincinnati and gave Henrietta free papers. While cooking for Mrs. Boyd's boarding-house Mrs. B. prevailed on her to ride in a hack with her over to Covington, where they were met by three negro traders, Willoughby Scott, (then of Bourbon) Frank Russ and Jabez (Zeb) Ward. They paid Mrs. B. money and took Henrietta with them to Florence where they gathered other negroes. A son of the Florence landlord learning from her that she was free, promised

HENRIETTA WOODS OF BOONE COUNTY, 1876. The recapture of fugitive African Americans became a major event for many local Northern Kentuckians. In this image, the April 8, 1876 edition of the *Covington Journal* notes the activities of a fugitive black American named Henrietta Woods, who traveled through Northern Kentucky and Ohio to elude numerous slave catchers. (Courtesy of the Boone County Historical Society.)

SLAVE OWNERS IN BULLITTSBURG BAPTIST CHURCH
from the minutes of
Bullittsburg Baptist Church
Boone County, Kentucky
This list includes the 106 slaves (and their owners) who became members of the church as of May 1813. There are 113 slaves' names on the three-page list, but 7 of them were excluded and then later restored.

Owner. Number of slaves who were members. Slaves names.
1. William Cave 4 [Lucy, Harry, Lydia, Milley]

2. John Taylor 7 [Nanny, Asa, Ben, Dublin, Lettice (Lettie), Jacob, Judith]

3. John Graves 7 [Esther, Winnefert, Selay, Nelly, Roger, Ben, Juda]

4. James Ryle 2 [Harry, Rachel]

5. Jeremiah Kirtley [Curry]

6. Joseph Hawkins [Rachel]

7. Robert Piatt [Rose]

A LIST OF SLAVES FROM THE BULLITTSBURG BAPTIST CHURCH. There is no question that the ownership of a person of color crossed every boundary throughout Northern Kentucky, even into the religious sector. The various names, genders, and ages on this Bullittsburg Baptist Church document illustrates how slavery and religion often intertwined to reinforce the system of human bondage. (Courtesy of the Boone County Historical Society.)

19

The Case of Joseph

1825

From the Minutes of the Sand Run Baptist Church:

22 Jan 1825

Bro. Joseph Graves brought in a complaint against Joseph a black member belonging to bro. B. Deulany for striking a man with a stone. Also another complaint by bro. McCoy against the said bro. Joseph for stealing turkeys from bro. Harvey, for which he was tried before a magistrate & publicly whipt, the matter was taken up first in relation to the first charge, for which he acknowledged he was guilty of sin: Secondly in relation to the second charge (which he deneyed) the church found him guilty of sin in this charge also. Satisfaction was not obtained. Therefore in consideration of both charges he was excluded.

MINUTES OF THE SAND RUN BAPTIST CHURCH—THE CASE OF JOSEPH, 1825. The punishment associated with being found guilty of resisting the system of enslavement was ever present in the minds of African-American captives. This narrative clearly describes how Joseph was charged with striking a man with a stone and the punishment associated with this activity. (Courtesy of the Boone County Historical Society.)

Daily Commonwealth 5 May 1884 p. 1, col. 6.

JUDGE LYNCH

Holds a Brief Term in Boone County, Ky.

A Bad Man Taken From Jail and Hanged.

Sunday morning last, between 1 and 2 o'clock, twenty masked men went to the jail at Burlington, Boone county, Ky., took therefrom a young colored man named Charles Dickerson, and hung him. Dickerson was a notorious thief and withal a desperate man. The Walton correspondent of THE COMMONWEALTH has had repeated occasion to mention his daring exploits. In March last he broke into the house of Mr. Hioes, an old pensioner, and secured $200 of the veteran's money. He was arrested and committed to the Burlington jail, from which he made his escape. At an early hour of the morning of the 28th of April three burglars entered the store of Mr. John Conner, at Walton. Mr. Conner was on the watch and called to his assistance Mr. Curley and Mr. Northcutt. A conflict ensued between these gentlemen and the burglars. Several shots were fired, and one of the burglars was shot in the knee and captured. The others made their escape. The wounded burglar proved to be Charles Dickerson. In the fight there were some narrow escapes. A ball fired from a heavy Colt's revolver, by one of the burglars, aimed at Mr. Conner, missed him and passing through the heavy plate glass in the door of Mrs. Martha A. Fry's dwelling imbedded itself in the opposite wall.

These occurrences, showing the desperate character of Dickerson, caused the greatest excitement, and at the time of the attempt to rob Conner's store there were threats of lynching. Dickerson made a full confession, in which he implicated several other negroes. The jail door was forced and Dickerson hurried from his cell and into the midst of the mob outside, many of whom were armed. At a distance of about a mile to the east of Burlington there stands a lofty walnut tree, on which the negro who murdered Mr. Frederick Wall, was hung a year or two ago, and toward this the mob with the culprit bent its way. To the very same branch from which the murderer formerly hung the rope was adjusted, a noose was formed, and Dickerson was swung up without ceremony. The body was found hanging there yesterday morning, and was subsequently cut down and turned over to the Coroner.

A LYNCHING IN BOONE COUNTY, 1884. Obviously, the ultimate punishment for enslaved persons of color resisting the institution of slavery was death. This May 5, 1884 issue of the *Daily Commonwealth* describes the punishment received by Charles Dickerson because of his occupation as a "notorious thief." (Courtesy of the Boone County Historical Society.)

Suit by John Norris of Petersburg, 1850

SLAVE SUIT.—John Norris, of Boone county, Ky., recovered a judgment of $2,800 last week in the U. S. Circuit Court at Indianapolis against NEWLAN, CROCKER, and others, for slaves which it was alleged they had abducted from NORRIS at South Bend, Ky. NORRIS had followed his negroes to that place, and had them again in possession, when they were taken from him by force. The costs of the suit are about $2,000, which added to the $2,800 damages, make $4,800.

Covington Journal 22 Jun 1850 p. 2, col. 2

JOHN NORRIS'S COURT CASE, 1850. This June 22, 1850 edition of *Covington Journal* shows through the case of John Norris that the exchanges between people who owned slaves and those who had money occurred quite regularly in Northern Kentucky. (Courtesy of the Boone County Historical Society.)

Runaway Slaves in Michigan

INFAMOUS!

It will, perhaps be remembered, that several weeks ago we announced the elopement of some 20 or 30 Slaves from this county.

A short time since information was received by their owners, that the runaways were colonized in a small town in the southern part of Michigan.

A party of some 12 or 15 gentlemen, composed principally of those who had sustained the loss, immediately repaired to that place, and succeeded in finding and recapturing their slaves without difficulty. But no sooner had they taken them into custody than they were surrounded by a furious mob of several hundred abolitionists who treated them with every indignity which cowardly brutality could invent, rescued the slaves from them by force, and had a mock trial before a Judge who had previously sworn that they should not take the negroes away in any event, the result of which was that the slaves were immediately turned loose and the Kentuckians confined and forced to give bail under charges of kidnapping, rioting &c. We intend to publish next week a full narrative of this most atrocious piece of abolition villainy, the details of which cannot fail to make the blood of every honest man boil in his veins. Things have indeed come to a startling condition when such conduct is not only allowed to pass unpunished, but actually receives the sanction of public approval in the North. The time may come when those cowards and sons of cowards will again, as during the last war, turn their imploring eyes to Kentucky and to Kentuckians for protection from the ravages of a foreign foe; and they may then find that Kentucky has no more Shelby's Johnsons Dudleys and Clays, to march to their frontier at the head of her heroic and devoted armies, for the protection of a vile den of Negro thieves and recreants to every principle of honor and common honesty—to say nothing of gratitude.

Licking Valley Register
3 Sept 1847 p. 2, col. 1

RUNAWAY EDITORIAL, **1847.** Some runaways from Kentucky ventured north into Michigan and began to form their own segregated communities. The development of this type of environment did not stop various slave catchers from doing their job, as the September 3, 1847 issue of the *Licking Valley Register* illustrates. (Courtesy of the Boone County Historical Society.)

Two

THE POWER
OF SPIRITUALITY

THE NINTH STREET BAPTIST CHURCH. In 1869, a group of African-American residents from Covington formed the Ninth Street Baptist Church. Despite great damage to the building as a result of the great flood of 1937, the church still stands today. Pictured here is this house of worship during its early years. (Courtesy of the Frank W. Steely Library, Northern Kentucky African American Heritage Task Force Collection, Northern Kentucky University.)

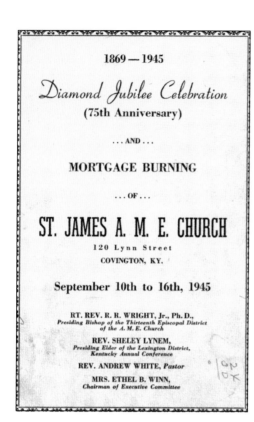

1869 — 1945

Diamond Jubilee Celebration
(75th Anniversary)

...AND...

MORTGAGE BURNING

...OF...

ST. JAMES A. M. E. CHURCH

120 Lynn Street
COVINGTON, KY.

September 10th to 16th, 1945

RT. REV. R. R. WRIGHT, Jr., Ph. D.,
*Presiding Bishop of the Thirteenth Episcopal District
of the A. M. E. Church*

REV. SHELEY LYNEM,
*Presiding Elder of the Lexington District,
Kentucky Annual Conference*

REV. ANDREW WHITE, *Pastor*

MRS. ETHEL B. WINN,
Chairman of Executive Committee

ST. JAMES AME CHURCH 75TH ANNIVERSARY CELEBRATION. In 1918, a building was constructed and soon became the new St. James AME Church. Several decades later, in 1943, ground was broken for the development of a larger facility that was finished in 1945. Pictured is the celebration flyer of the great event. (Courtesy of the Frank W. Steely Library, Northern Kentucky African American Heritage Task Force Collection, Northern Kentucky University.)

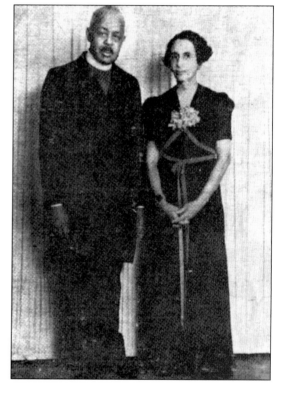

A POWERFUL MINISTRY TEAM. At the time of St. James AME Church's opening in 1945, Bishop R.R. Wright Jr. was the "new" pastor. He and his wife are pictured here. (Courtesy of the Frank W. Steely Library, Northern Kentucky African American Task Force Collection, Northern Kentucky University.)

DEED

Know All Men By These Presents:

CLERK'S OFFICE
SHORT ★ FORM
DEED

That ANDREW KNOX, RANDOLPH POPE and IDA BELL WASHINGTON, Successor Trustees of Ninth Street Baptist Church, Covington, Kentucky

for and in consideration of $1.00 & other valuable considerations to them paid by the grantees herein, the receipt of which is acknowledged, do bargain, sell, and convey to:

NINTH STREET BAPTIST CHURCH, INC., a Kentucky corporation, its successors

DEED OF NINTH STREET BAPTIST CHURCH, COVINGTON. The ownership of the Ninth Street Baptist Church changed somewhat frequently during its existence. This 1907 church deed notes the names Andrew Knox, Randolph Pope, and Ida Bell Washington. However, the church changed hands again in 1942 and 1956. (Courtesy of the Frank W. Steely Library, Northern Kentucky African American Heritage Task Force Collection, Northern Kentucky University.)

BEING all of Lots 160, 161, 162, ~~163 & 164~~ and 163 of Foote's Second Subdivision, each of said lots fronting 25 feet on the south side of Ninth Street and extending back 86.5 feet.

Being the same property conveyed to the Trustees of Ninth Street Baptist Church by deed from the Master Commissioner in the Kenton Circuit Court, dated October 28, 1907, recorded in Deed Book 130, page 555, and all of the same property conveyed to the Trustees of the Ninth Street Baptist Church by deed from Georgia Lytle Truitt, et al, dated January 25, 1956, and recorded in Deed Book 443, page 39; and being all of the property conveyed to the Trustees of Ninth Street Baptist Church by deed from Economy Building Association, dated May_____, 1942, and recorded in Deed Book 296, page 314, all references being to the Kenton County Clerk's records at Covington, Kentucky. The Grantors herein are the successor trustees of the Ninth Street Baptist Church to the trustees named in the foregoing deeds. The purpose of this conveyance is to place title of record clearly in the Grantee herein, a Kentucky corporation.

Property Transfer Tax Paid $ *Exempt*
A. T. WOOD, Clerk _____ D.C.

Together with all the PRIVILEGES AND APPURTENANCES to the same belonging.

TO HAVE AND TO HOLD the same to the said NINTH STREET BAPTIST CHURCH, INC., a

Kentucky corporation, its successors

NINTH STREET BAPTIST CHURCH, COVINGTON. Large plots of land are a must when building a church. According to its 1907 deed, this was the case with the construction of the Ninth Street Baptist Church. For example, several lots ranging from 25 to 86.5 feet were used in this particular venture. (Courtesy of the Frank W. Steely Library, Northern Kentucky African American Heritage Task Force Collection, Northern Kentucky University.)

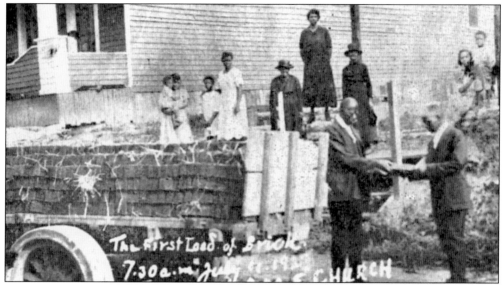

THE BUILDING OF ST. JAMES AME CHURCH. Shown here is the construction of the first permanent building for the St. James AME Church. Before this facility was erected, the congregation traveled from place to place to worship. However, under the leadership of Rev. J.A.G. Grant, this situation changed forever. (Courtesy of the Frank W. Steely Library, Northern Kentucky African American Heritage Task Force Collection, Northern Kentucky University.)

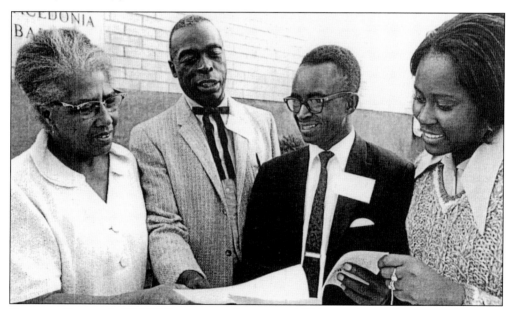

NORTHERN KENTUCKY'S NAACP CONVENTION, COVINGTON, 1971. Worship and praise took various forms within the numerous African American churches of Northern Kentucky. Pictured here are four individuals, Jane Summers, James Griffin, the Reverend H.P. Johnson, and Arrie Powell, who were on their way to a special service at the Northern Kentucky NAACP convention in Covington. (Courtesy of the Frank W. Steely Library, Northern Kentucky African American Heritage Task Force Collection, Northern Kentucky University.)

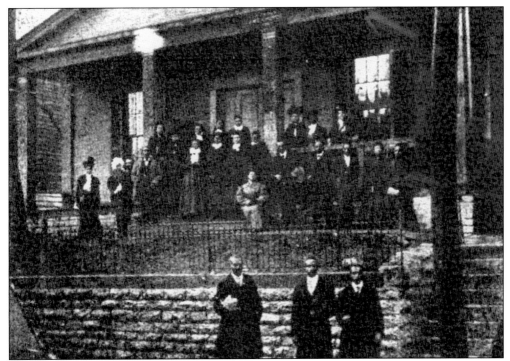

THE FIRST CONGREGATION OF ST. JAMES AME. The original pastoral staff and congregation gather for a photo opportunity in front of the first permanent St. James AME Church structure. At least 30 individuals attended this event. (Courtesy of the Frank W. Steely Library, Northern Kentucky African American Heritage Task Force Collection, Northern Kentucky University.)

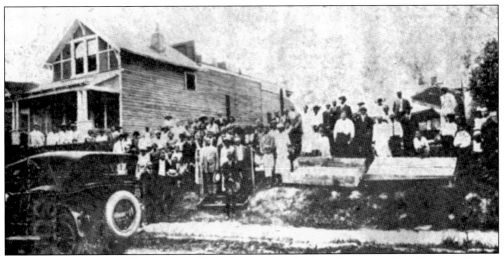

THE ESTABLISHMENT OF A FOUNDATION. This photograph depicts the groundbreaking service on the lot where St. James AME was to be built during the early 1920s. An estimated crowd of about 100 local residents and church members attended this ceremony. (Courtesy of the Frank W. Steely Library, Northern Kentucky Heritage Task Force Collection, Northern Kentucky University.)

27

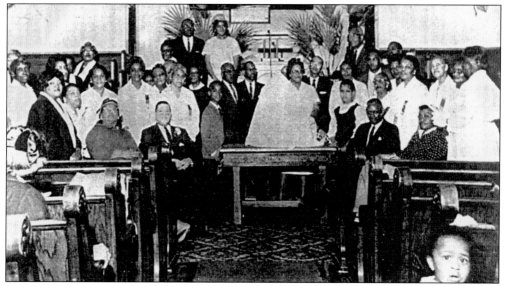

FIRST BAPTIST CHURCH OF COVINGTON, KENTUCKY. In this 1966 photograph, the members of First Baptist Church of Covington include Bertie Moore, Ms. Webb, Ms. Graves, Hattie Givens, Catherine Williams, Mrs. Martin, Marie Pettis, Deacon Tomlison, Deacon Clayburn (sitting), Mrs. Jenkins, Deacon Belton, Cornell Clayburn (sitting), Ms. Clayburn (sitting), Deacon Jasper, Reverend Halbert (pastor), Deacon Johnson, Mrs. Johnson, Viola Bryant, and Emma Jackson. (Courtesy of the Frank W. Steely Library, Northern Kentucky African American Task Force Collection, Northern Kentucky University and the Behringer-Crawford Museum.)

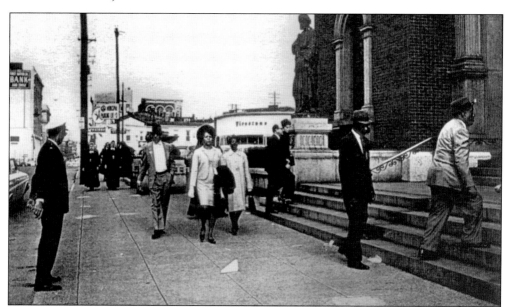

MOTHER GOD CATHOLIC CHURCH. In 1968, the Mother God Catholic Church of Covington held a memorial service for Dr. Martin Luther King Jr. Several hundred individuals from the surrounding tri-state region were in attendance. (Courtesy of the Kenton County Public Library.)

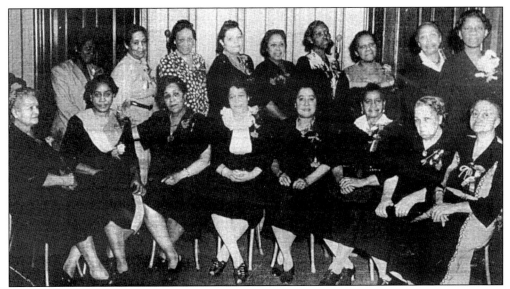

THE SUNSHINE CLUB. Members of the Sunshine Club were, from left to right, (standing) Mrs. David, Anna Mae Walkins Snowden Jones, Mrs. Mabel Smith, Ethel Baker Winn, Mrs. Estella Shannon, Mae Johnson, Mary E. Allen, and Mrs. Alberta Watkins; (sitting) Eleanor Henderson, Mrs. Russell, Elizabeth W. Gooch, Vinia Wells, Lula McClain, Catherine Williams, Blanche Irene Glenn, Mrs. Miranda Robinson, and Etta Low Hundley. (Courtesy of the Kenton County Public Library.)

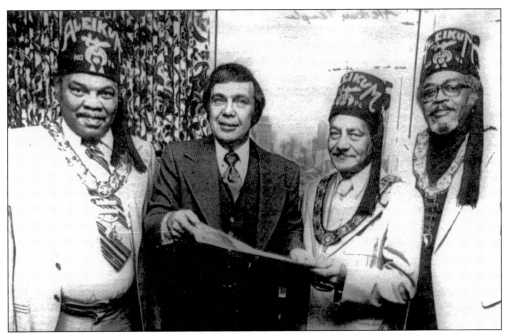

ALEIKUM TEMPLE. The local chapter of the Aleikum Temple brought a unique brand of spirituality and leadership to the local African-American community in Covington during the 1960s and 1970s. This photograph shows several of the key members. (Courtesy of the Kenton County Public Library.)

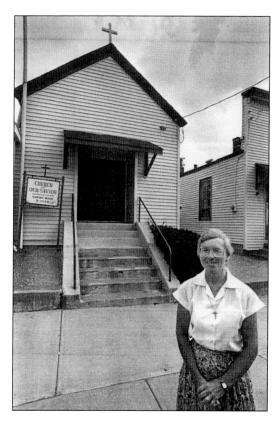

OUR SAVIOR CATHOLIC CHURCH. As was the case with many Northern Kentucky residents, the Catholic faith played a very important role in the lives and communities of numerous African Americans. Pictured here is Our Savior Catholic Church of Covington. This church was constructed in 1943 on East Tenth Street in Covington. (Courtesy of the Boone County Public Library.)

FR. RAYMOND MCCLANAHAN. Fr. Raymond McClanahan was a mainstay at Our Savior Catholic Church for many years. His presence and influence reached various segments of the city of Covington. He is shown here during a communion service with several children and teenagers. (Courtesy of the Kenton County Public Library.)

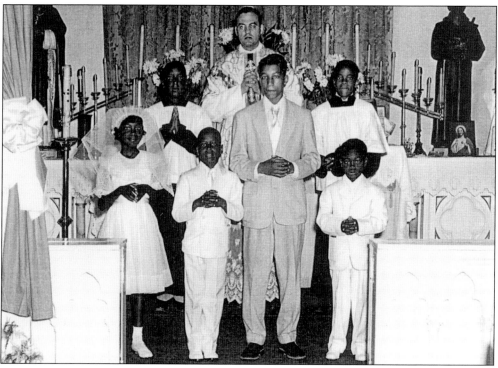

OFFICIAL CHURCH RECORD

Permanent Membership Roll

In Loose Leaf

BOOK 4

Same forms as used in the Official Book No. 2

Prepared under the authority of the General Conference of 1916
(Journal, 1916, pp. 359, 575)

THE METHODIST BOOK CONCERN
NEW YORK CINCINNATI

A CHURCH MEMBERSHIP LEDGER. The staff of most African-American churches in Northern Kentucky meticulously documented membership on a regular basis. As a result, hundreds of records are available that reveal the size and composition of a particular congregation. Displayed here is one of those documents. (Courtesy of the Frank W. Steely Library, Northern Kentucky African American Heritage Task Force Collection, Northern Kentucky University.)

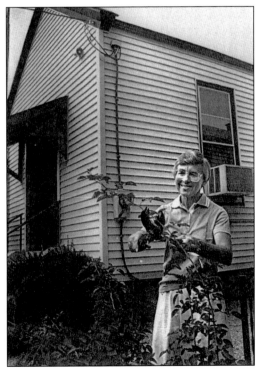

SISTER JANET BUCHER. A very important member of the Our Savior Catholic Church was Sister Janet Bucher. As a teacher and local activist, Sister Bucher advocated for racial equality and social justice for all people. (Courtesy of the Kenton County Public Library.)

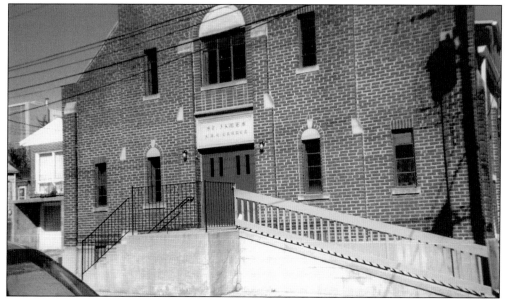

ST. JAMES AME CHURCH. As a result of its enormous growth in population, in 1986, the St. James AME Church, led by Rev. (Dr.) Edgar L. Mack, was renovated and remodeled to include a large educational resource center and various other additions, as well as more room for its congregation. Today, this facility stands as a major institution within the black American community of Covington. (Courtesy of Dr. Eric R. Jackson.)

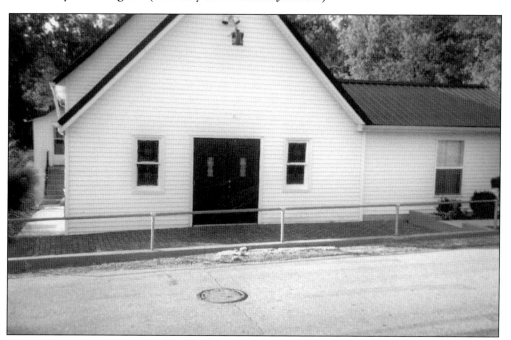

MOUNT ZION BAPTIST CHURCH. Established in 1872 as a church and school for local African Americans, the Mount Zion Baptist Church, located in Walton, Kentucky, still serves its congregation as a powerful voice for justice and freedom in Northern Kentucky. (Courtesy of Dr. Eric R. Jackson.)

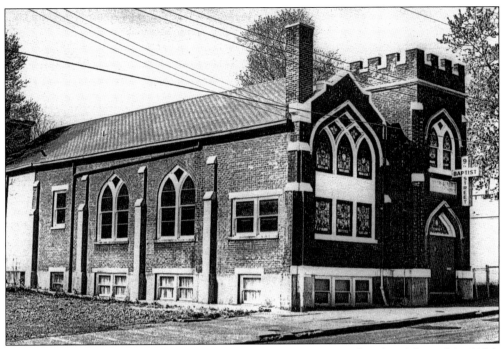

NINTH STREET BAPTIST CHURCH. In 1989, the Ninth Street Baptist Church celebrated its 100th anniversary. Numerous African-American community leaders attended this great event. This photograph shows the facility several years prior to this affair. (Courtesy of the Kenton County Public Library.)

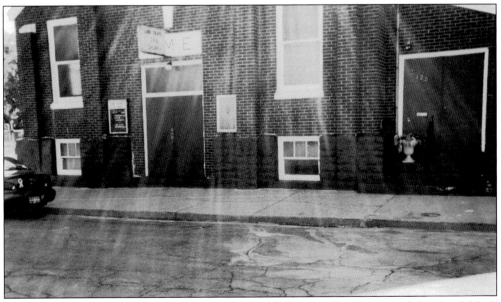

LANE CHAPEL AME CHURCH. On December 15, 1894, several members of the local black American community of Covington led a powerful effort to establish the Lane Chapel AME Church of Covington. Moved to its present location, 125 Lynn Street, in 1976, this institution continues to serve its congregation and community today. (Courtesy of Dr. Eric R. Jackson.)

33

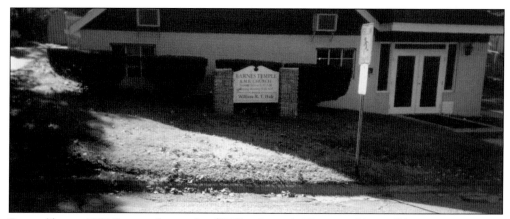

BARNES TEMPLE AME CHURCH. Located at 437 Fox Street in Elsmere, this small but very important church can trace its origins back to the emergence of the first African Methodist Episcopal church, started by Richard Allen and Absalam Jones in Philadelphia in 1794. (Courtesy of Dr. Eric R. Jackson.)

BARNES TEMPLE AME CHURCH. The Barnes Temple AME Church played an enormous role in the establishment, development, and well being of the local black American community in Elsmere, Kentucky. (Courtesy of Dr. Eric R. Jackson.)

Three

EMPLOYMENT OPPORTUNITIES

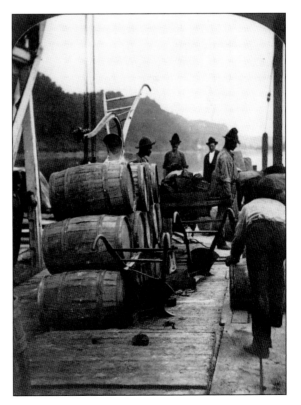

AFRICAN-AMERICAN STEAMSHIP LOADERS.
During the early 19th century, the
major transportation system that led
to the rapid expansion and economic
transformation of the areas west of
the Appalachian Mountain region
was the steamboat. Moreover, the
steamboat became the fastest way
to transport numerous items from
town to town and region to region.
Many African Americans participated
in this process in Northern Kentucky.
Pictured here are several black
Americans loading or unloading
barrels from a vessel. (Courtesy of
Virginia Bennett.)

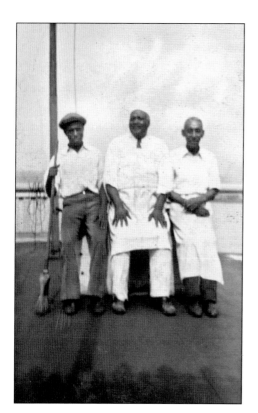

AN AFRICAN-AMERICAN STEAMBOAT COOK AND HIS CREW. During the 1930s and 1940s, numerous steamboats traveled along the Ohio River. Several of these vessels contained African-American crewmen. Here rest George Beckley, Jim Dowdell, and Lloyd Grimes, who sailed on the *Gordon C. Greene* steamer. (Courtesy of Virginia Bennett.)

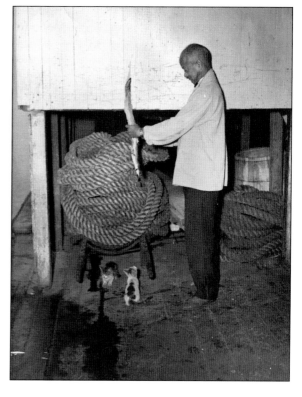

A BLACK AMERICAN DOCKWORKER ON A STEAMSHIP. One of the major tasks that African Americans performed on steamships sailing down the Ohio River was feeding the crewmen. This photograph shows a kitchen worker holding a fish. (Courtesy of Virginia Bennett.)

LLOYD GRIMES. For a time during the 1930s and 1940s, Lloyd Grimes, pictured here in his uniform, helped to cook meals for the crewmen of numerous steamboats that traveled the Ohio River. (Courtesy of Virginia Bennett.)

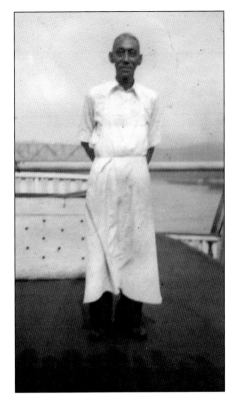

AFRICAN-AMERICAN LABORERS. With various advancements in the steamboat industry during the 1840s and 1850s, trips between long distances became faster and cheaper. Also during these years, trips from Northern Kentucky to southwestern Ohio became quite regular. Shown here are several African-American laborers unloading a vessel in Rome, Ohio. (Courtesy of Virginia Bennett.)

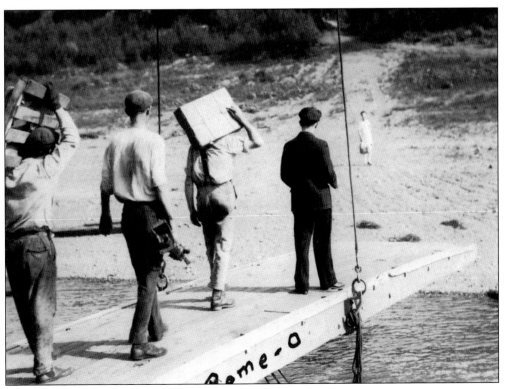

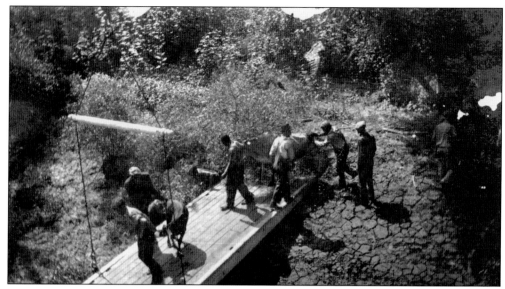

LOADING HORSES. The continuous use of the steamboat enabled various companies and individuals to transport livestock very long distances with ease. Here, several black Americans perform this task. (Courtesy of Virginia Bennett.)

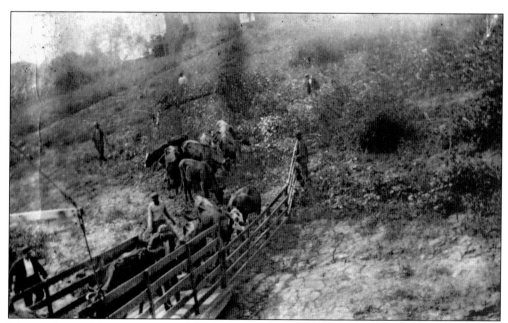

MOVING CATTLE. The movement of cattle onto steamboats was very difficult at times. Often, such curious animals would not cooperate. Nevertheless, those African Americans who were involved in these activities had no choice but to perform this assignment. (Courtesy of Virginia Bennett.)

AN AFRICAN-AMERICAN POLE MAN. Once a steamboat reached the dock, someone had to help guide the ship to a stop so that the vessel was not damaged. Here, an African-American pole man is preparing to do this. (Courtesy of Virginia Bennett.)

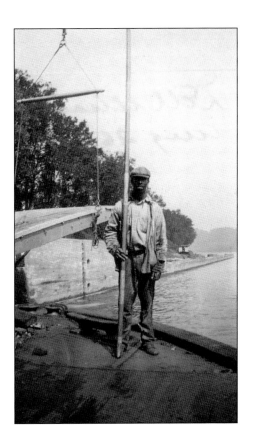

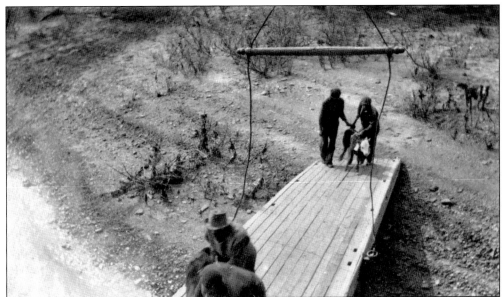

AFRICAN-AMERICAN DOCKWORKERS LOADING CATTLE. On many occasions, crewmen had to work as teams to make sure that livestock was placed on the steamship in a timely and orderly fashion. (Courtesy of Virginia Bennett.)

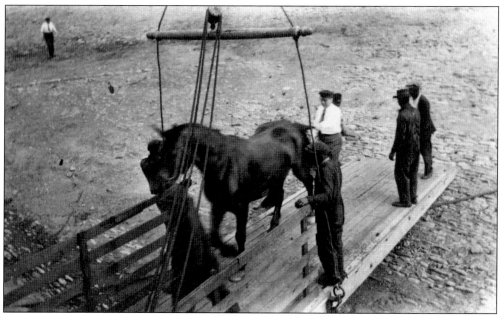

WORKERS ON THE RIVER. One of the most complex jobs for a steamship loader was to place a horse on the vessel. Those people involved in this activity had to make sure the animals were tied properly, lifted, and placed on the ship unharmed. The beginning of the assignment is shown here. (Courtesy of Virginia Bennett.)

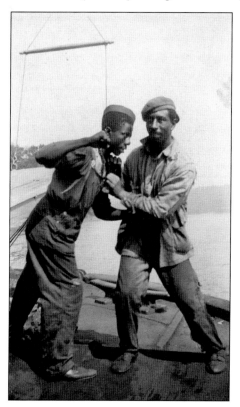

AFRICAN-AMERICAN SHIPMEN AT PLAY. Occasionally, to release stress or to break up the daily routine, black American crewmen tried to entertain themselves through various means. This photograph shows two African Americans pushing each other. (Courtesy of Virginia Bennett.)

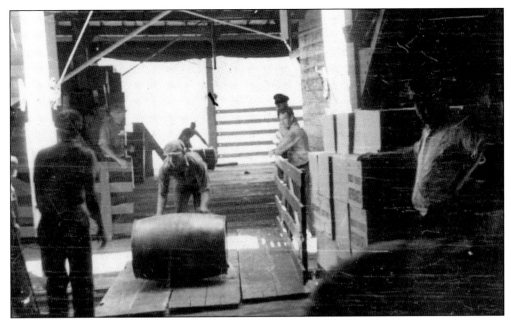

AFRICAN-AMERICAN STEAMBOAT LOADERS. The placement of manufactured goods and raw material on steamships took many forms. Many individuals preferred the use of barrels for this task. Displayed here are several African Americans loading such items. (Courtesy of Virginia Bennett.)

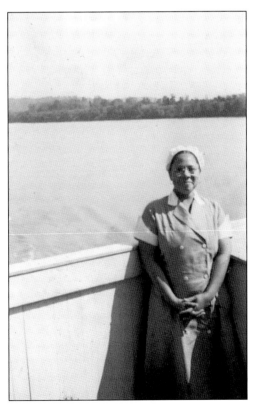

AFRICAN-AMERICAN HEAD MAID. At times, African-American women worked on steamships as maids or kitchen workers. As with African-American men, black women on steamships usually performed stereotypical roles. The woman pictured here in uniform is known only as Bertha. (Courtesy of Virginia Bennett.)

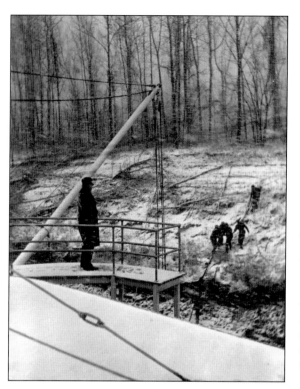

AN AFRICAN-AMERICAN SHOREMAN.
Sometimes, a steamship sailed into a rough and unfamiliar dock to deliver or obtain cargo or individuals. During these times, it was imperative that a crewman observe the situation before the ship docked, as is shown here. (Courtesy of Virginia Bennett.)

AFRICAN-AMERICAN STEAMBOAT CREW.
Black Americans who chose to work on steamboats varied in height, weight, and strength. Such individuals also wore a variety of clothing attire based on the weather. This photograph shows several African-American crewmen in short-sleeved shirts and work pants ready to work. (Courtesy of Virginia Bennett.)

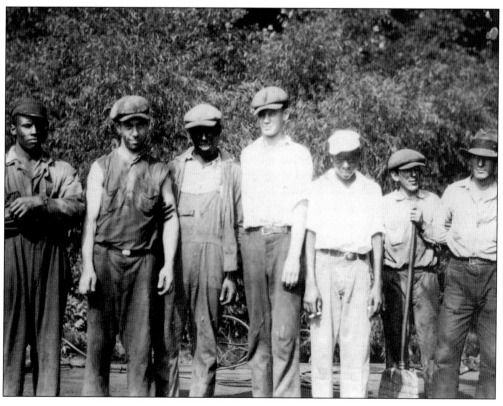

AN AFRICAN-AMERICAN CAPSTONE DOCKWORKER. Steamboats known as packets regularly traveled the Ohio River between specific ports and towns in Northern Kentucky. These vessels were frequently tied to the dock with secure precision. On occasion, an African American was given this assignment. (Courtesy of Virginia Bennett.)

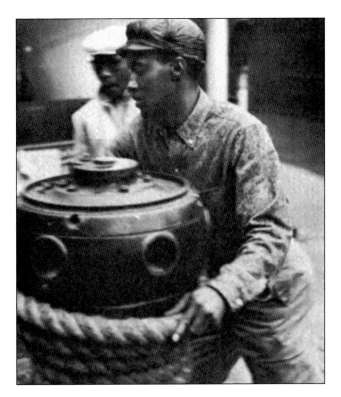

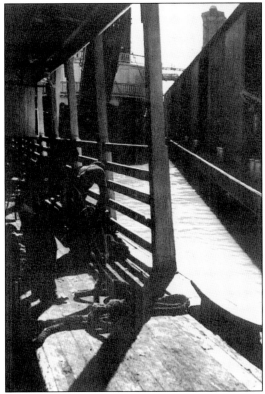

AN AFRICAN-AMERICAN CREWMAN. This photograph shows an African-American crewman at the beginning stage of making sure that the steamship was secure to the dock using a rope. (Courtesy of Virginia Bennett.)

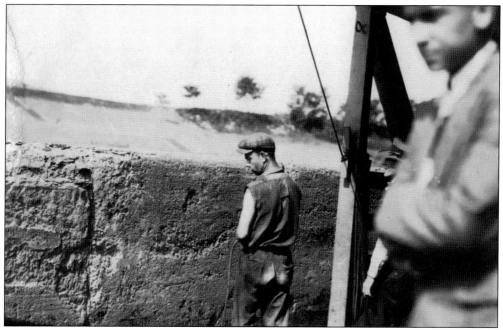

An African-American Lock-Wall Coordinator. Some steamboats that traveled to harbors, river towns, or big cities had to be tied to a lock wall for security reasons. Here is a photograph of a black American crewman performing this duty during the 1920s or 1930s. (Courtesy of Virginia Bennett.)

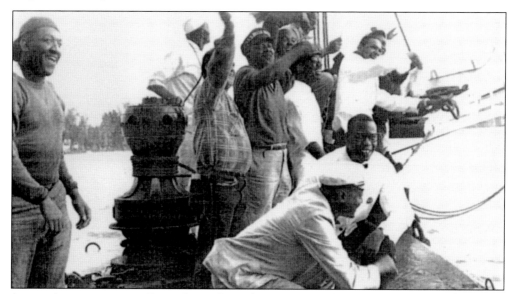

African Americans and the *Delta Queen*. Steamboats were used not only to transport livestock, manufactured goods, or raw material. These vessels were also a comfortable way to travel across the country. Some people viewed steamboats as moving hotels or apartments. A primary example was the *Delta Queen*, which traveled along and across the Ohio River. Pictured here are several of its African American crewmen. (Courtesy of the Mickey Frye Collection, Behringer-Crawford Museum.)

THE *DELTA QUEEN* SAILS ALONG.
Steamboats such as the *Delta
Queen* almost always had a large
number of passengers aboard as
they traveled up and down the
Ohio River. A number of local
African Americans made a good
living as crewmen on these
ships. (Courtesy of the Mickey
Frye Collection, Behringer-
Crawford Museum.)

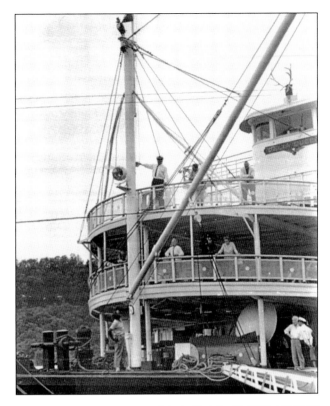

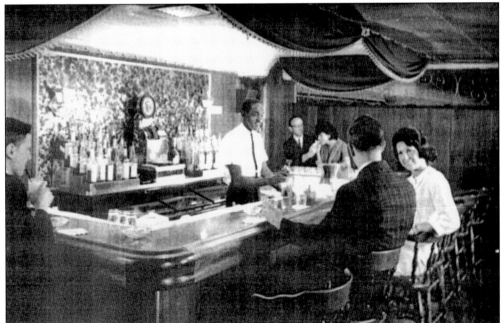

JOHN DAVIS AND THE *DELTA QUEEN*. Pictured in this photograph is bartender John Davis. He is
serving several guests of the *Delta Queen* during the late 1960s. (Courtesy of the Mickey Frey
Collection, Behringer-Crawford Museum.)

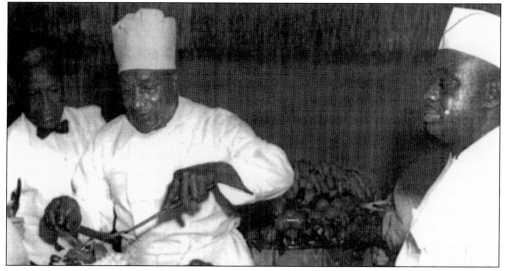

WALTER HICKS AND THE *DELTA QUEEN*. Many of those who traveled on the *Delta Queen* during the 1960s had the pleasure of being fed in the New Orleans Room. Here, chef Walter Hicks is serving one of his famous meals. (Courtesy of the Mickey Frye Collection, Behringer-Crawford Museum.)

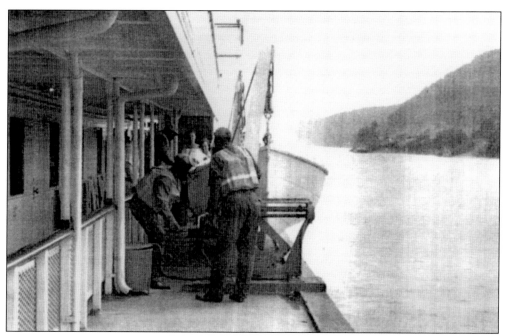

BOAT DRILL ON THE *DELTA QUEEN*. The crewmen of the *Delta Queen* had to be prepared for any and all emergencies. This photograph shows several crewmen dressed in get-up-and-go uniforms, practicing lowering the life boat. (Courtesy of the Mickey Frye Collection, Behringer-Crawford Museum.)

Jerome Hawkins and the *Delta Queen*. This photograph shows Jerome Hawkins serving coffee to a passenger on the *Delta Queen*. (Courtesy of the Mickey Frye Collection, Behringer-Crawford Museum.)

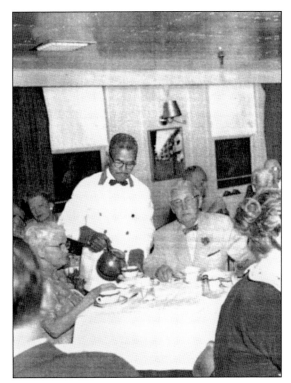

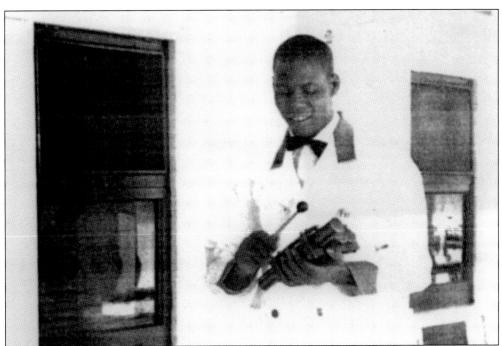

A Steward with a Bell. Occasionally, bells were used on board the *Delta Queen* to signal various stops or other important messages or events. Here, steward Rubin Pilot rings the bell. (Courtesy of the Mickey Fry Collection, Behringer-Crawford Museum.)

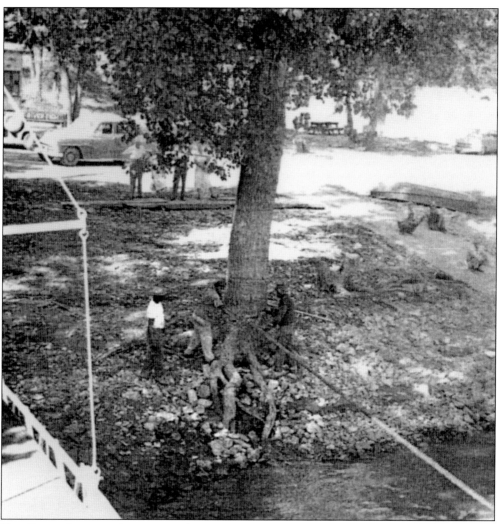

THE *DELTA QUEEN* IN ILLINOIS. Without question, steamships traveled far distances from their home ports. As a result, many African-American Northern Kentuckians had the opportunity to visit places that they had not seen before. This photograph shows the *Delta Queen* being tied up at a stop in Illinois. (Courtesy of the Mickey Frye Collection, Behringer-Crawford Museum.)

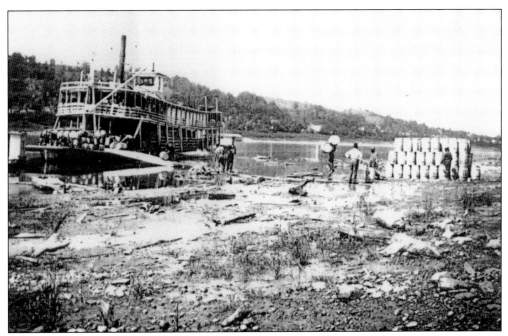

UNLOADING CARGO. Most African-American steamboat workers had to obtain employment wherever possible. For many of these individuals, loading and unloading barrels onto a vessel was fine. (Courtesy of the Mickey Frye Collection, Behringer-Crawford Museum.)

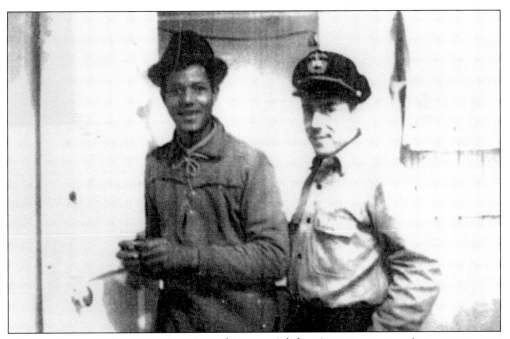

CROSSING RACIAL BARRIERS. On steamships, racial barriers, to a certain extent, were eliminated. This photograph shows an African-American crewman and a Caucasian captain, Clarke C. "Doc" Hawley, together. (Courtesy of the Mickey Frye Collection, Behringer-Crawford Museum.)

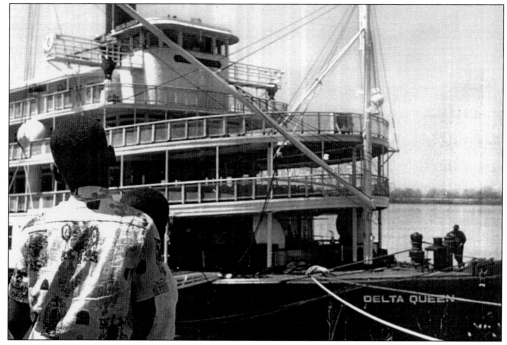

DELTA QUEEN FASCINATES ALL. The structure, height, length, and overall look of a steamship fascinated almost all observers. Here, two unidentified African-American children are very focused on this majestic vessel. (Courtesy of the Mickey Frye Collection, Behringer-Crawford Museum.)

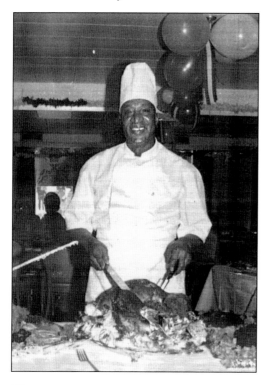

WALTER HICKS AT WORK. As the primary chef on the *Delta Queen*, Walter Hicks seems to be enjoying every aspect of his job. (Courtesy of the Mickey Frye Collection, Behringer-Crawford Museum.)

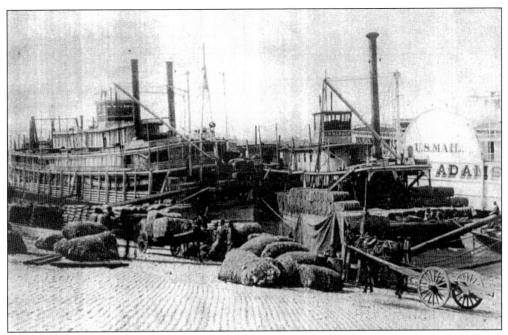

WORKERS DESERVE TO REST. Despite the hectic schedule and enormous amount of material that needed to be loaded on a steamship, occasionally the laborers had to rest. (Courtesy of the Mickey Frye Collection, Behringer-Crawford Museum.)

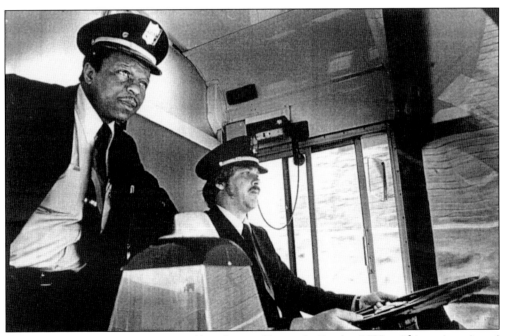

WILSON MCDONALD (STANDING) AND TOM BRAUN (DRIVING). By the 1980s, African Americans' economic opportunities had expanded into all areas. Pictured here is Wilson McDonald, observing the road and teaching student bus driver Tom Braun. (Courtesy of the Kenton County Public Library.)

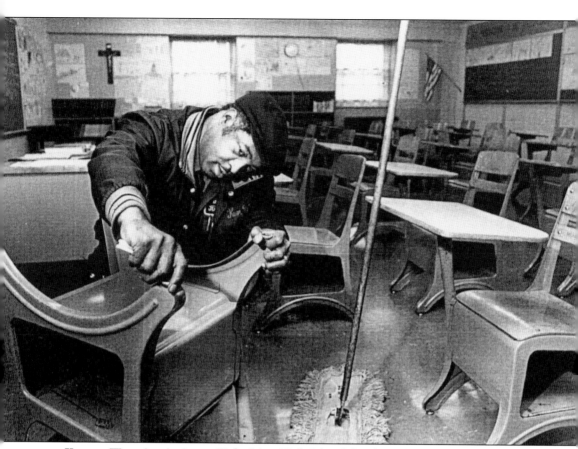

KENNETH WEFF. As a janitor at Holy Cross High School, local resident Kenneth Weff took great pride in his work and various assignments. (Courtesy of the Kenton County Public Library.)

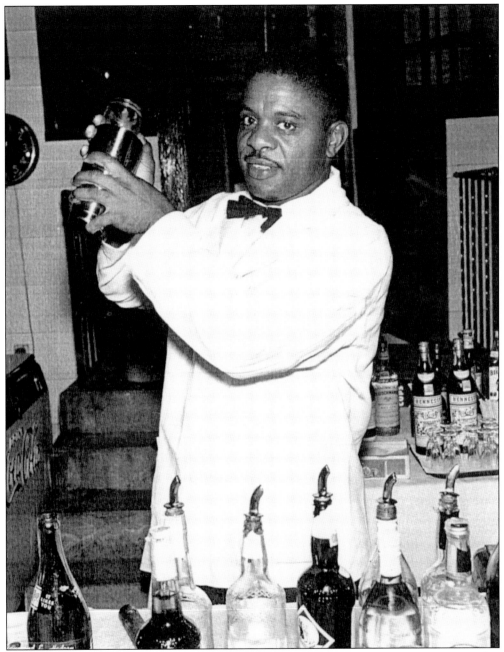

RAYMOND E. HADORN. Pictured here is photographer, bartender, and wedding specialist Raymond E. Hadorn. His business, located in Covington, was a mainstay of the African-American business district for many years. (Courtesy of the Kenton County Public Library.)

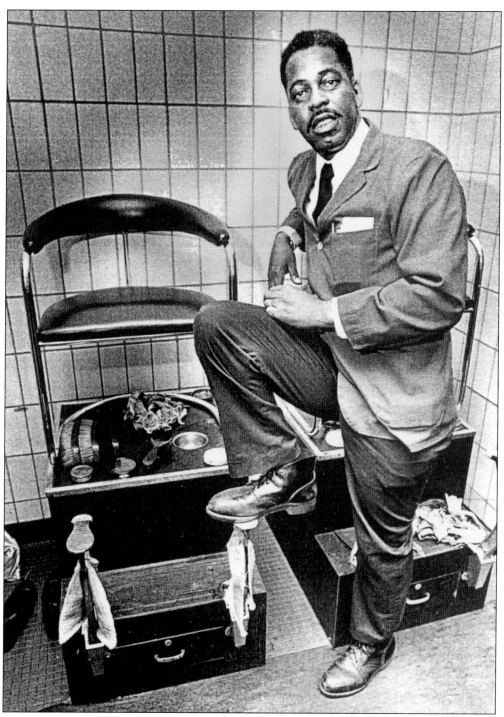

CHARLIE WATKINS. One of the first African Americans to work at the Greater Cincinnati Airport was Charlie Watkins, who was a shoe shiner and shoe repairman in 1978. In that position, he dealt with various obstacles but persisted in his quest to make the situation better for those who would follow him. (Courtesy of the Kenton County Public Library.)

Four

Education
and Schools

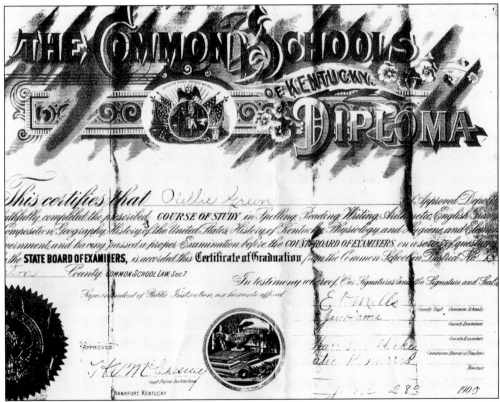

A "Common School" Diploma. During the early 1900s, Northern Kentucky's public school system rested in racial segregation. African Americans who wanted an education attended various substandard and poorly funded facilities. Despite this arrangement, many students did succeed in their quest to obtain a quality education. For instance, Boone County resident Nellie Green received her "common school" diploma. (Courtesy of the Erlanger Historical Society.)

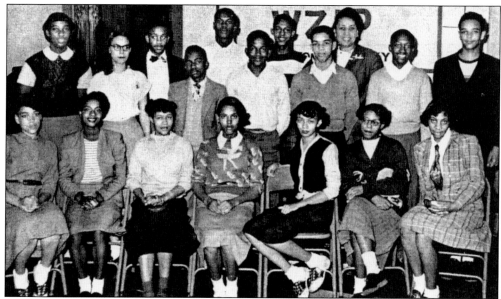

LINCOLN GRANT SCHOOL SPEECH TEAM, 1950. Pictured from left to right are (front row) Mary Hall, Peggy Williams, Betty Jones, Bettye Mills, Bernice Lee, Mary W. Webb, and Ella Allen; (middle row) Mary M. Webb, Juanita Griffin, Millard Garrett, William Hargraves II, Robert Rhodes, Devolsia Williams, and Frank Deal; (back row) Richard Jarman, Norman Reid, Clarence Morris, and J.R. Jackson (faculty advisor). (Courtesy of the Northern Kentucky African American Heritage Task Force Collection, Frank W. Steely Library, Special Collections, Northern Kentucky University.)

DUNBAR SCHOOL. The first black public school in Elsmere, located on Spring Street, was named for the famous African-American poet and writer Paul Laurence Dunbar. This one-room building was used to educate many neighborhood children. Dunbar School operated until the Wilkins School was created in 1948. (Courtesy of the Erlanger-Elsmere Board of Education.)

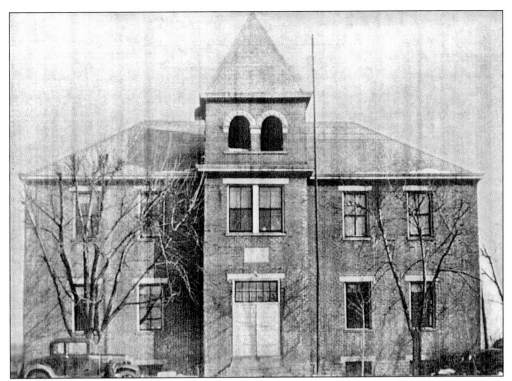

ELSMERE GRADED SCHOOL. Originally built in 1899 but remodeled during the 1920s, this multi-story school building housed many local students. As a result of its location in Erlanger-Elsmere, for a time some African-American students did attend this facility. (Courtesy of the Erlanger-Elsmere Board of Education.)

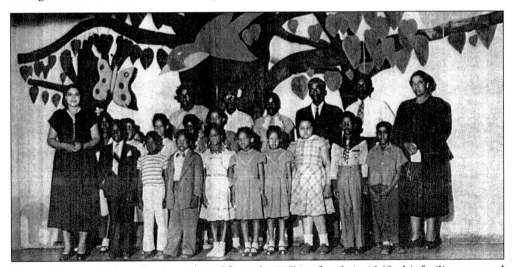

WILKINS SCHOOL. Built on land purchased from the Wilkins family in 1948, this facility operated as a segregated school until the 1954 *Brown* decision. Pictured here are (at left) Mrs. Rosella Porterfield, who served as a teacher, principal, and librarian for a time, and (at right) Mrs. Wilma Porterfield, who also was a longtime teacher. (Courtesy of the Erlanger-Elsmere Board of Education.)

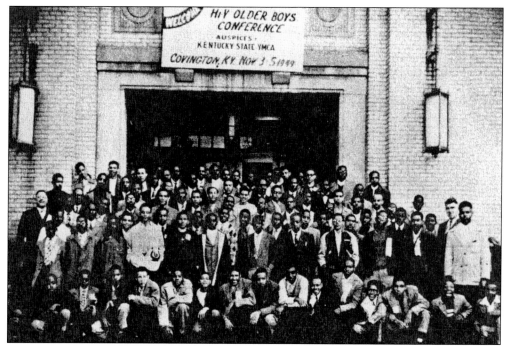

HIGH SCHOOL HI-Y CLUB. Pictured is an annual Hi-Y conference at Lincoln Grant School in 1950. One of the issues that this organization stressed to its members was the value and importance of community service. (Courtesy of the Northern Kentucky African American Heritage Task Force Collection, Frank W. Steely Library, Special Collections, Northern Kentucky University.)

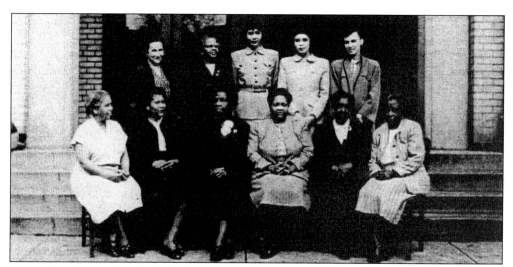

LINCOLN GRANT ELEMENTARY SCHOOL FACULTY. Pictured in 1950, from left to right, are (front row) E. Wilson, C. Bowers, E. Hundley, A. Vaughn, C. Williams, and M. Corbin; (back row) A. Hargraves, C. Taylor, G. Gamble, D. Jackson, and M. Beaver. (Courtesy of the Northern Kentucky African American Heritage Task Force Collection, Frank W. Steely Library, Special Collections, Northern Kentucky University.)

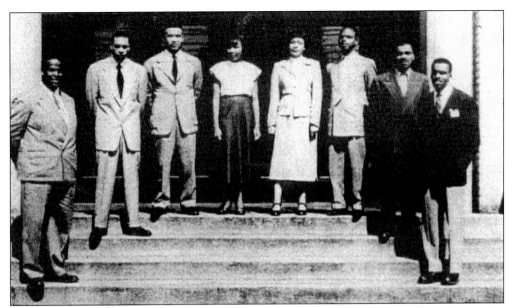

LINCOLN GRANT STUDENT TEACHERS. This photograph shows student teachers, from left to right, S. Sheffey, L. Cavil, C. Lett, N. Green, S. Gilliard, C. Hines, W. McClellen, and W. Gilliard. (Courtesy of the Northern Kentucky African American Heritage Task Force Collection, Frank W. Steely Library, Northern Kentucky University.)

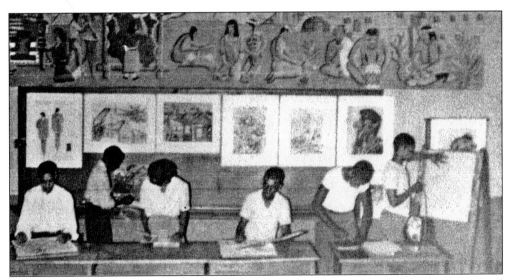

LINCOLN GRANT ART CLASS. Students enrolled in this course learned to paint, plaster, and develop an appreciation for the fine arts. The six pupils pictured here are working quite diligently on their projects. (Courtesy of the Northern Kentucky African American Heritage Task Force Collection, Frank W. Steely Library, Northern Kentucky University.)

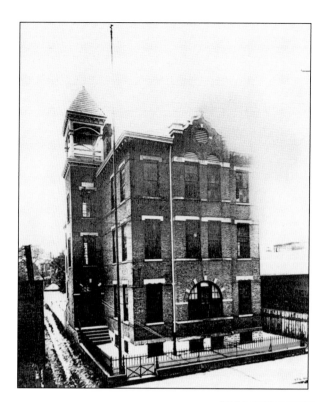

SEVENTH STREET "COLORED" SCHOOL. During the late 1880s to the early 1900s, this school was used to educate hundreds of Covington's African-American students from the 6th to 12th grade. Later this facility not only provided knowledge to the black American student population of Covington but also some pupils from various African-American neighborhoods in the nearby towns of Newport and Erlanger-Elsmere. (Courtesy of the Kenton County Public Library.)

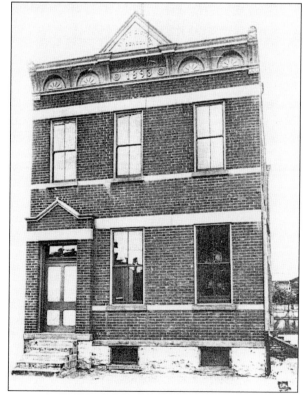

SOUTHGATE STREET SCHOOL. Built in 1873, Southgate Street School was established to provide educational opportunities for African-American elementary grade students in Newport and the surrounding communities. In 1901, this facility was remodeled to include a high school that remained in operation until 1921, when the student population was transferred to Lincoln Grant in Covington. (Courtesy of the Kenton County Public Library.)

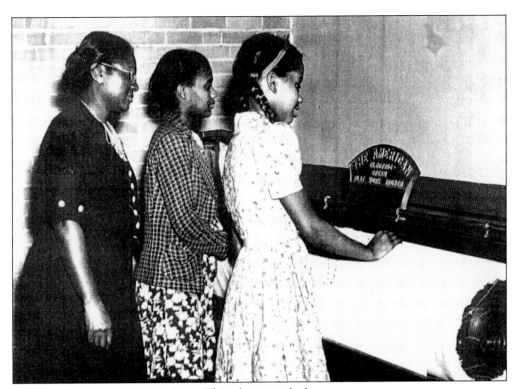

LINCOLN GRANT DOMESTIC ARTS CLASS. This photograph shows students Mae White and Florence Johnson as well as teacher Eleanor Henderson engaged intensely in a domestic arts (home economics) assignment at Lincoln Grant School, *c.* 1941. (Courtesy of the Northern Kentucky African American Heritage Task Force Collection, Frank W. Steely Library, Northern Kentucky University.)

M.L. MARTIN, 1963. During the 1960s, M.L. Martin served as principal at Lincoln Grant School. His presence and leadership abilities helped to fortify the school's prestigious educational reputation throughout the region and state of Kentucky. (Courtesy of the Kenton County Public Library.)

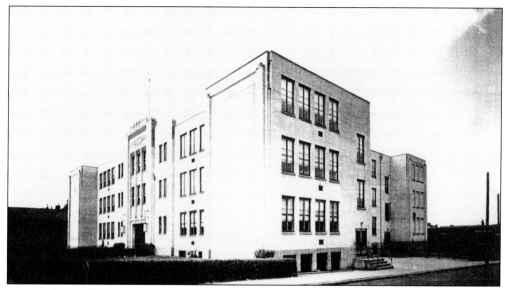

LINCOLN GRANT SCHOOL, 1932. In 1932, Lincoln Grant School opened the doors of a newly refurbished facility that was located on Greenup Street in Covington. Its auditorium was named after a prominent African-American entrepreneur, Charles E. Jones. Many credited the school's high academic standards to the special environment that developed between students, teachers, parents, and overall local African-American community. (Courtesy of the Kenton County Public Library.)

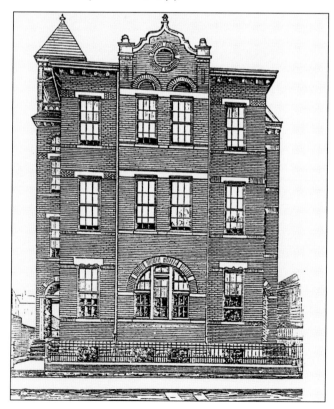

SEVENTH STREET "COLORED" SCHOOL. During the 1880s, many African-American children were able to quench their thirst for quality education at the Seventh Street "Colored" School. By 1888, the school had an enrollment of 319 pupils. Several years later, in 1893, the attendance reached 439. (Courtesy of the Kenton County Public Library.)

LINCOLN GRANT STUDENT COUNCIL. Students who enrolled in Lincoln Grant School were able to obtain a variety of skills in community outreach and leadership. The school's student council, pictured here, was one way these abilities were obtained. (Courtesy of the Northern Kentucky African American Heritage Task Force Collection, Frank W. Steely Library, Northern Kentucky University.)

LINCOLN GRANT FACULTY MEMBERS. The high achievement scores of many Lincoln Grant students were directly tied to the incredible array of knowledge, talent, and advance degrees held by its faculty, for example, (top) Jewell R. Jackson, University of Cincinnati, M.E.; and William N. Jackson, Atlanta University, M.S.; (middle) William F. Hargraves, Miami University, M.A.; and Roscoe C. Vaught, University of Wisconsin, M.A.; (bottom) Birtill T. Barrow, Columbia University, M.A. (Courtesy of the Northern Kentucky African American Heritage Task Force Collection, Frank W. Steely Library, Northern Kentucky University.)

63

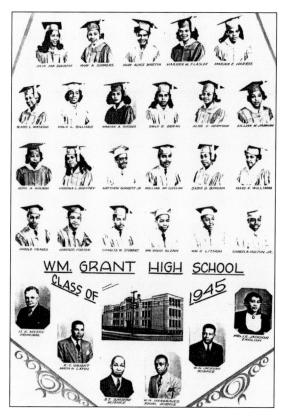

LINCOLN GRANT SCHOOL GRADUATES.
Pictured here is the 1945 graduating
class of Lincoln Grant School. On
the front row, from left to right,
are H.R. Merry (principal), R.C.
Wright (math and Latin teacher),
B.T. Barrow (science teacher), W.H.
Hargraves (social science teacher),
W.N. Jackson (science teacher), and
Mrs. J.R. Jackson (English teacher).
(Courtesy of the Northern Kentucky
African American Heritage Task Force
Collection, Frank W. Steely Library,
Northern Kentucky University.)

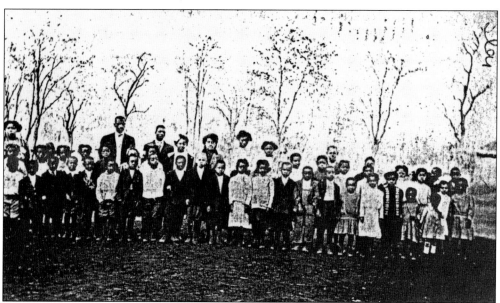

SOME ELEMENTARY SCHOOL STUDENTS. This picture shows some elementary school students
standing on the side of a rural school during the late 1890s or early 1900s. (Courtesy of
the Northern Kentucky African American Heritage Task Force Collection, Frank W. Steely
Library, Northern Kentucky University.)

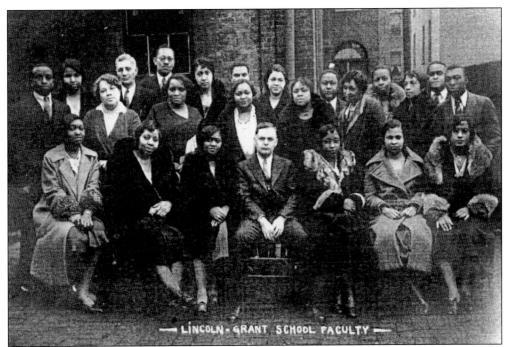

LINCOLN GRANT FACULTY. This photograph shows the faculty of Lincoln Grant School during the 1950s. Seated in the center is Principal H.R. Merry. (Courtesy of the Northern Kentucky African American Heritage Task Force Collection, Frank W. Steely Library, Northern Kentucky University.)

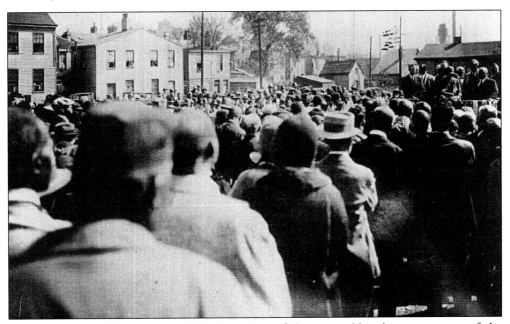

BUILDING LINCOLN GRANT SCHOOL. This is a view of the ground-breaking ceremony of the new Lincoln Grant School. Pictured are hundreds of local African-American residents near Greenup Street in Covington. (Courtesy of the Kenton County Public Library.)

Certificate of Promotion

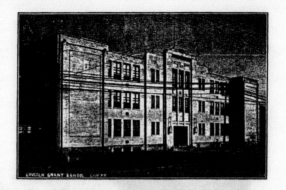

LINCOLN-GRANT SCHOOL

This is to Certify that

Marion A. Rhodes

has satisfactorily completed the Course of Study in the Kindergarten Department and is hereby promoted to the First Grade. In testimony whereof

This Certificate is presented.

Done in Covington, Kentucky, on the ___9th___ of June 193 _3_

Virginia Kalfus
Teacher

H. R. Merry
Principal

A CERTIFICATE OF PROMOTION. In 1933, Marion A. Rhodes became one of the first students to advance from kindergarten to the first grade at Lincoln Grant School. Shown here is her certification of promotion, which recognizes this accomplishment. (Courtesy of the Northern Kentucky African American Heritage Task Force Collection, Frank W. Steely Library, Northern Kentucky University.)

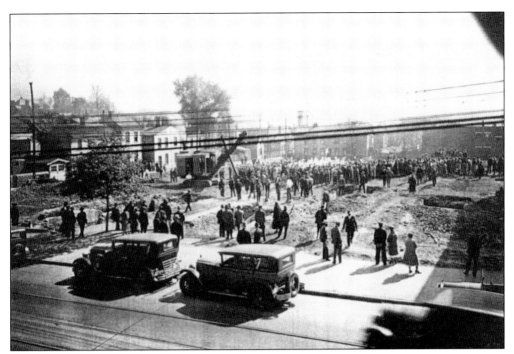

GROUNDBREAKING FOR LINCOLN GRANT SCHOOL. This photograph shows the 1932 groundbreaking ceremony for the Lincoln Grant School of Covington, where numerous local African Americans gathered to watch the event. On the stage were several community and school board members. (Courtesy of the Kenton County Public Library.)

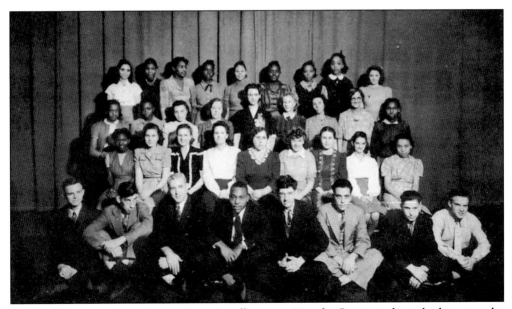

MARIAN HARRIS AND EMILY BREAN. Occasionally, some Lincoln Grant students had to attend a nearby educational institution in Cincinnati, Ohio, to obtain some specialized training. Shown here are Marian Harris (far left, second row) and Emily Brean (far right, second row) with their "typing I" classmates from Rostrum High School. (Courtesy of Mary Northington.)

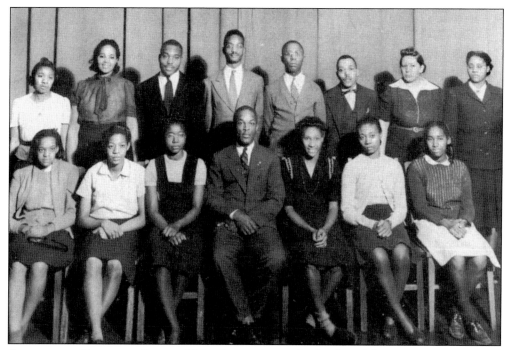

STUDENTS AND COMMUNITY SERVICE. This picture shows the Student Advancement Association of Rostrum High School. Among various other concepts, this organization taught its members the value of community outreach and leadership. Two Lincoln Grant School students are seated here: Marian Harris (far left) and Emily Brean (far right). (Courtesy of Mary Northington.)

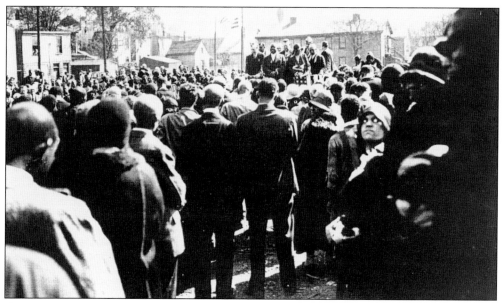

GROUNDBREAKING FOR LINCOLN GRANT SCHOOL. This 1932 photo shows the large crowd that gathered and attended the groundbreaking ceremony for the "new" Lincoln Grant School of Covington, Kentucky. (Courtesy of the Kenton County Public Library.)

LINCOLN GRANT FACULTY MEMBERS. Shown here from left to right are several 1950 Lincoln Grant faculty members: (first row) Eleanora W. Henderson and Samuel Gaines; (second row) Chester C. Rice and Sara Wright; (third row) Eunice Simpson and Paul L. Redden; (fourth row) Conrad Hutchinson Jr. and Mary G. Davis. (Courtesy of the Northern Kentucky African American Heritage Task Force Collection, Frank W. Steely Library, Northern Kentucky University.)

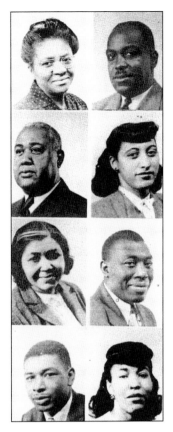

SALMON P. CHASE LAW SCHOOL. By the 1960s, integration had reached Kentucky's various colleges and universities. Pictured below is the first integrated class of Salmon P. Chase School of Law. At this time, the facility was located in Covington (Courtesy of Mary Northington.)

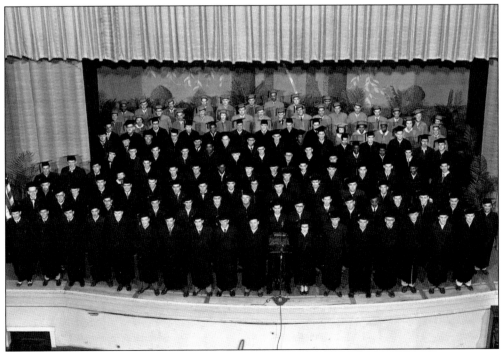

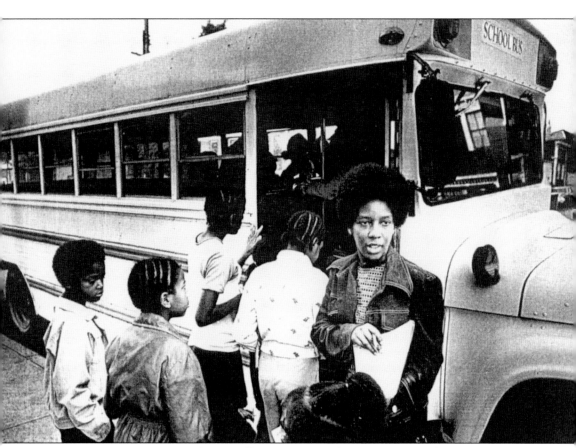

ESTELLA STEWART. Pictured is Estella Stewart, a school bus driver from Covington. This photograph, which appeared in the *Kentucky Post* in 1974, shows Stewart hard at work trying to make sure all her students board the bus safely. (Courtesy of the Kenton County Public Library.)

Five

THE ARTS, SPORTS, AND LEISURE

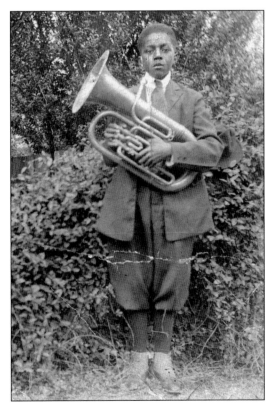

IVERY ("IVORY") WHATLEY. Despite the daily and intense presence of racial segregation, African-American Northern Kentuckians enjoyed themselves by creating an active and lively social life. Music was one of the main avenues in which this atmosphere emerged. Pictured here is a Covington resident named Ivery Whatley with his tuba. (Courtesy of Mary Northington.)

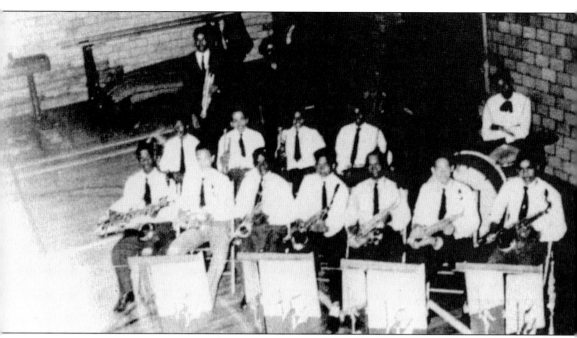

LINCOLN GRANT'S ORCHESTRA. Also known as the Booster Band Club, this ensemble, established in 1948 under the leader of Conrad Hutchinson Jr., helped to raise money for the Lincoln Grant music department and the purchase of uniforms for the school's marching band. In addition, this club held annual Christmas dances to generate more valuable funds. (Courtesy of the Northern Kentucky African American Heritage Task Force Collection, Frank W. Steely Library, Northern Kentucky University.)

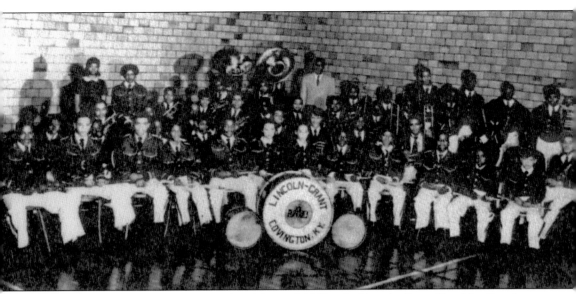

LINCOLN GRANT MARCHING BAND. During the 1940s and 1950s, the Lincoln Grant Marching Band performed at numerous school sports events and community engagements throughout the city of Covington. With a membership of over 50 students, this powerful assembly of talent brought much prestige to the school. (Courtesy of the Northern Kentucky African American Heritage Task Force Collection, Frank W. Steely Library, Northern Kentucky University.)

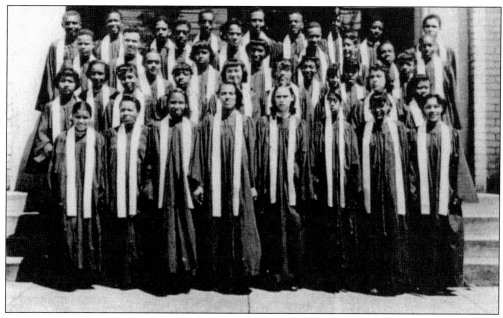

Lincoln Grant Choir. Lincoln Grant's musical talent was exhibited by the school's incredible choir. Under the direction of Elizabeth Gooch, this gifted collection of students performed at various venues in Covington. (Courtesy of the Northern Kentucky African American Heritage Task Force Collection, Frank W. Steely Library, Northern Kentucky University.)

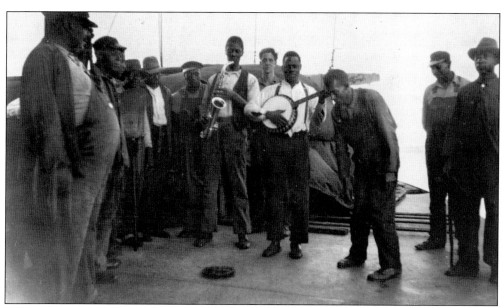

Dockworkers Perform. African-American dockworkers worked extremely hard and bonded together as brothers, and at times, they organized performances for the rest of the crew. These events, without question, offered many individuals a chance to exhibit their various talents and release stress from a difficult workday or week. (Courtesy of Virginia Bennett.)

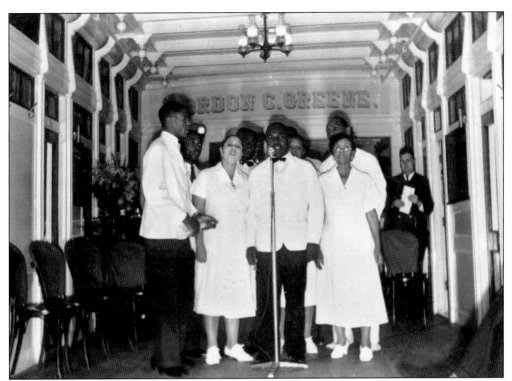

AFRICAN-AMERICAN STEAMBOAT SINGERS.
Black American steamboat workers
were not the only members of the
crew who performed. Pictured here
are a group of African American
maids and kitchen workers on the
Gordon C. Greene steamship singing
in front of a captive audience.
(Courtesy of Virginia Bennett.)

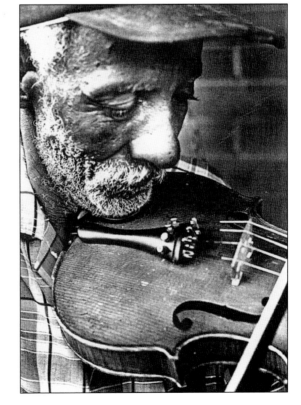

PLAYING FOLK MUSIC. Some African-
American Northern Kentuckians
listened to and played various types
of folk music. Pictured is a gentleman
enjoying himself with the musical
sounds of a violin. (Courtesy of the
Kenton County Public Library.)

The Willing Spiritual WZIP Radio Singers
OF COVINGTON, KY., SUNDAYS, 8:00 A. M.

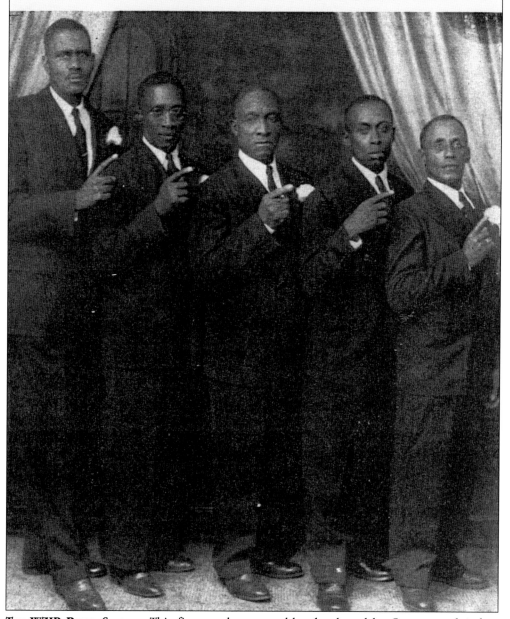

THE **WZIP RADIO SINGERS.** This five-member ensemble, developed by Carmen and Arthur Eilerman, thrilled hundreds of church members during the 1940s with their potent, inspirational, spiritual songs every Sunday morning. Shown here, from left to right, are A.Q. Gilliard, Ed Fisher, A. Williams, J.W. Kelly, and A.H. Smiley. (Courtesy of the Kenton County Public Library.)

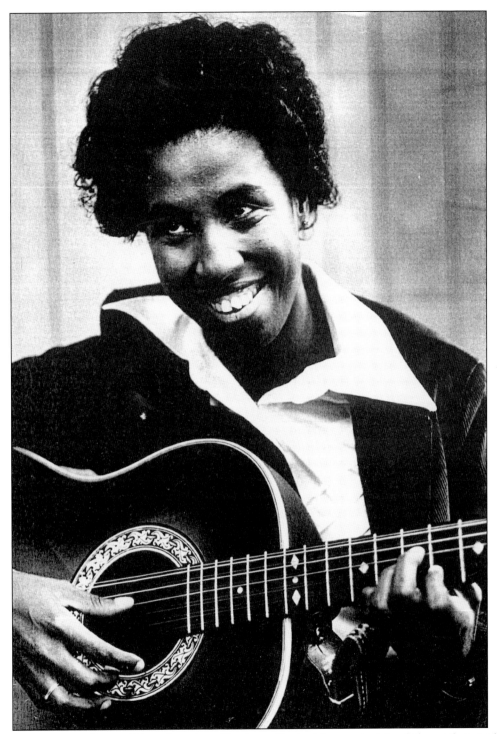

DIANE JENNINGS. Some African-American Northern Kentuckians entertained themselves and their community by playing the guitar. Pictured is guitar player Diane Jennings. (Courtesy of the Kenton County Public Library.)

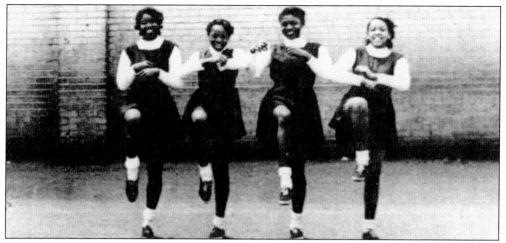

CHEERLEADERS. Entertaining the crowds that watch Lincoln Grant School's various sporting events was the primary goal of its cheerleaders. This group of skilled African Americans also formed bonds that lasted a lifetime. The photograph shows four members of the junior squad. (Courtesy of the Northern Kentucky African American Heritage Task Force Collection, Frank W. Steely Library, Northern Kentucky University.)

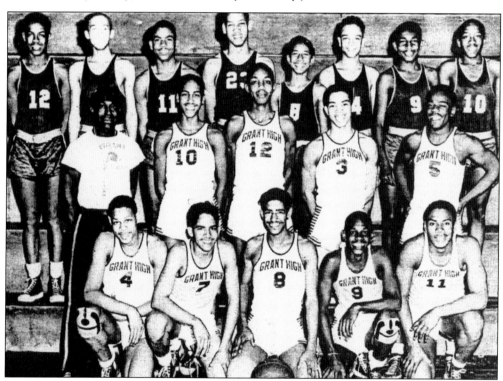

LINCOLN GRANT BASKETBALL. The sports teams of Lincoln Grant not only excelled athletically, but also generated much for the local black American community of Covington. Pictured in this 1950 photograph are the members of the Lincoln Grant basketball team. (Courtesy of the Northern Kentucky African American Task Force Collection, Frank W. Steely Library, Northern Kentucky University.)

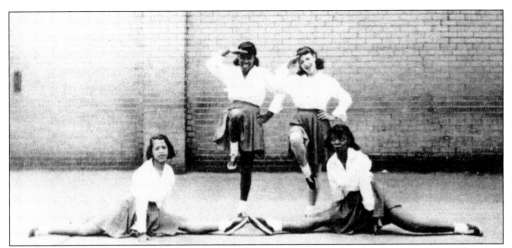

CHEERLEADERS AT LINCOLN GRANT. Pictured are several members of the 1950 senior cheerleading team of Lincoln Grant. This group performed not only at the school's various sporting events but also participated in several community functions. (Courtesy of the Northern Kentucky African American Task Force Collection, Frank W. Steely Library, Northern Kentucky University.)

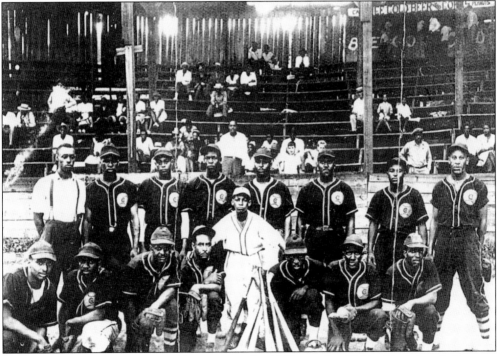

"TWENTY COUNT" BLACK BASEBALL TEAM. From the 1920s to the 1940s, black baseball teams appeared in almost every mid-sized town, including Covington. Pictured, from left to right, are (front row) Charles Stewart, Donald Jonsen, Hillard "Doughboy" Baskin, Vernon James, Robert Baughman, Raymond Gray, and "Cowboy" Gary; (back row) Marvin McIntrie, Jack Reed, Johnny Herndon, Otis Madrumn, Billy Lewis, Vic Elam, and Leon Watley. (Courtesy of the Kenton County Public Library.)

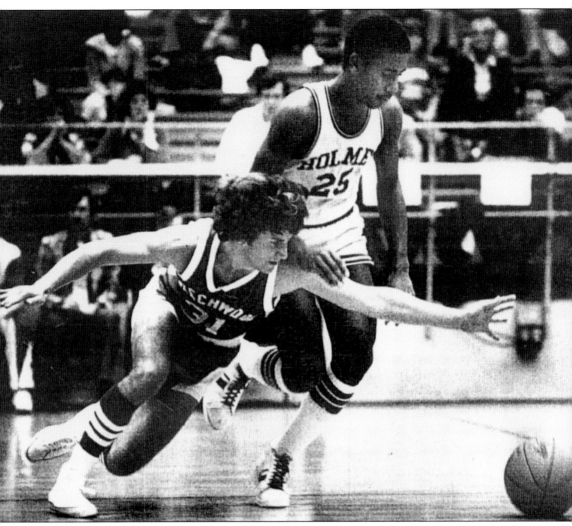

MARK ELMER. During the 1960s and 1970s, basketball games between nearby schools were major events for the local communities. Many people traveled long distances to see their favorite hometown team play. Pictured is a 1979 game between Holmes High School and Beechwood High School that featured local star Mark Elmer. (Courtesy of the Kenton County Public Library.)

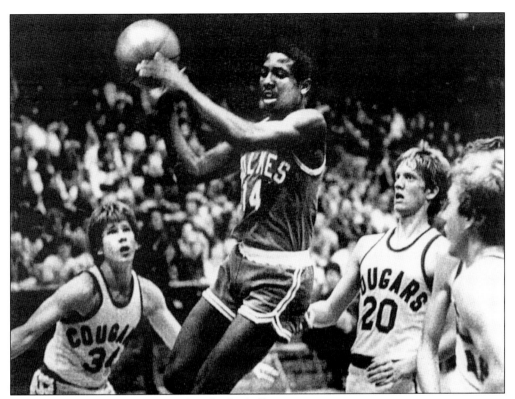

DICKEY BEAL. Pictured is the standout basketball star Dickey Beal. This 1979 *Kentucky Post* photograph shows Beal involved in a very hotly contested game between Covington's Holmes High School and Conner High School. (Courtesy of the Kenton County Public Library.)

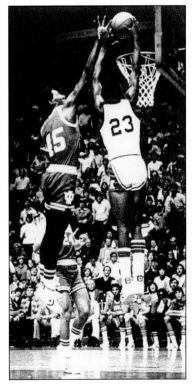

PLAYING BASKETBALL. The intense nature of basketball games eventually reached the college ranks. This photograph shows a game between the University of Kentucky and Indiana University only several decades after UK integrated their team. (Courtesy of the Kenton County Public Library.)

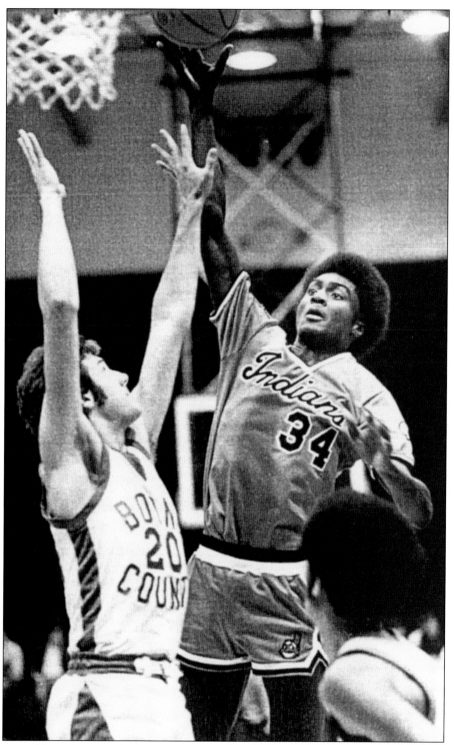

JUMP BALL. This photograph shows the intense nature of Northern Kentucky basketball at every turn. (Courtesy of the Kenton County Public Library.)

COMMUNITY BASKETBALL. Pictured at left is Coach Basey, the organizer of the Northern Kentucky Community Center basketball team, working with players Bobby Basey (center) and Scott Trammel in 1977. (Courtesy of the Kenton County Public Library.)

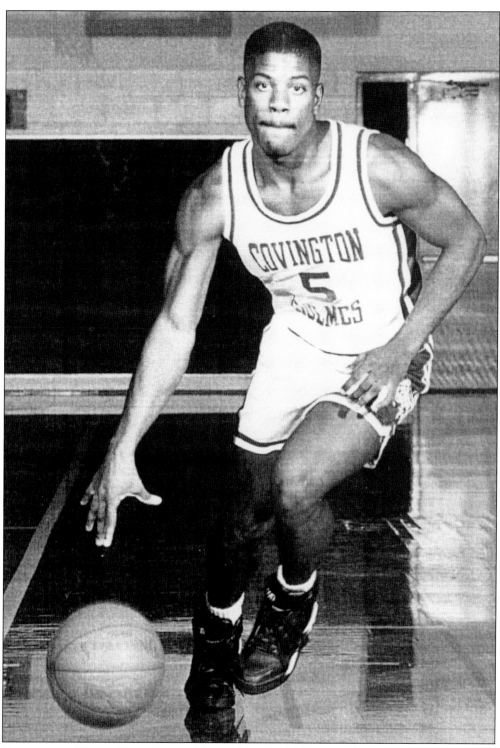

BASKETBALL AT HOLMES HIGH SCHOOL. This Holmes basketball star from Covington shows his intense workout routine to an audience. (Courtesy of the Kenton County Public Library.)

84

Six

COMMUNITY BUILDING

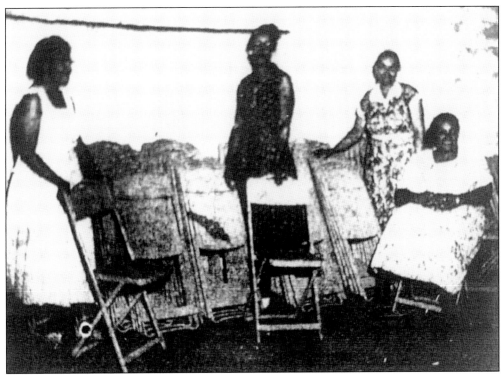

CIVIL LEAGUE. African-American women played a vital role in the establishment, development, and well being of numerous preeminent community institutions and organizations throughout Northern Kentucky. This 1957 photograph shows several members of the L.B. Fouse Civil League, located on 309 Bush Street in Covington. (Courtesy of the Kenton County Public Library.)

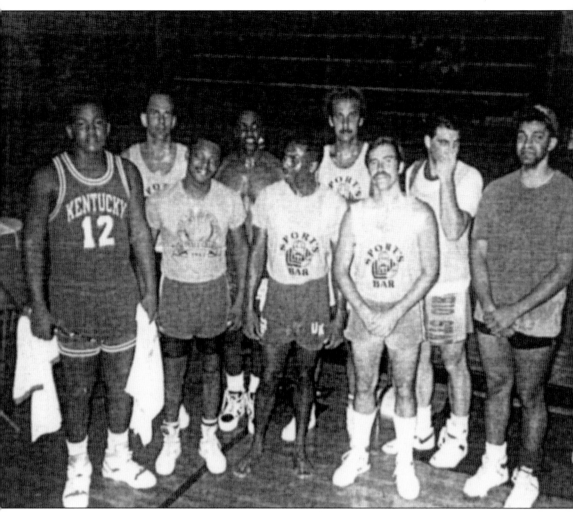

SCHLOMER BASKETBALL TEAM. During the 1980s, basketball games provided much-needed pride and unity for many African-American communities in Northern Kentucky. Pictured is the Schlomer Basketball Team. This squad took first place during a 1988 summer basketball tournament in Latonia, Kentucky.

THE SUNSHINE CLUB. Shown are several members of the Sunshine Club *c.* 1940. From left to right are (seated) Eleanor Henderson, Mrs. Russell, Elizabeth W. Gooch, Vinia Wells, Lulu McCain, Catherine Williams, Blanche Irene Glenn, Mrs. Norton, and Etta Lou Hundley; (standing) Mrs. David, Anna Mae Walkins, Mabel Smith, Ethel Baker Winn, Estella Shannon, Mae Johnson, Mary E. Allen, and Alberta Watkins. (Courtesy of the Kenton County Public Library.)

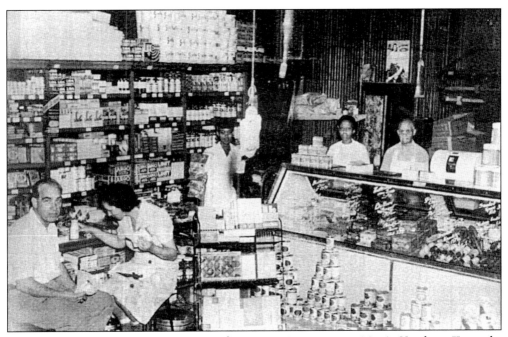

GENE BESS LACY GROCERY STORE. In most African-American communities in Northern Kentucky during the 1930s and 1940s, many important and critical local businesses emerged. In Covington, a prominent one was the Gene Bess Lacy Grocery Store. Shown here is an internal scene. (Courtesy of the Kenton County Public Library.)

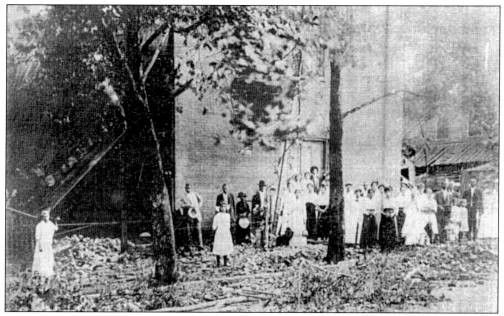

FIRST BAPTIST CHURCH. The 1915 tornado was one of the worst disasters recorded in Northern Kentucky. This photograph shows the enormous destruction that it caused to the First Baptist Church of Covington, then located on Russell Street. (Courtesy of the Kenton County Public Library.)

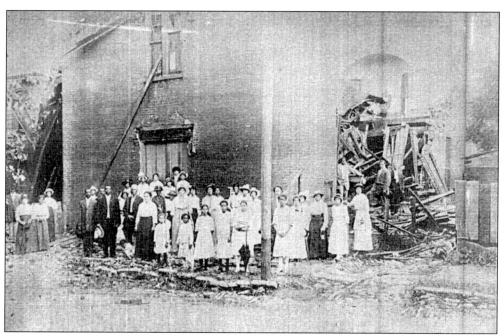

FIRST BAPTIST AND THE TORNADO. Pictured are several church members and many local residents of Covington viewing the massive damage caused by the erratic tornado of 1915, which almost completely destroyed the First Baptist Church. First Baptist at this time was pastored by Rev. F.C. Locust. (Courtesy of the Kenton County Public Library.)

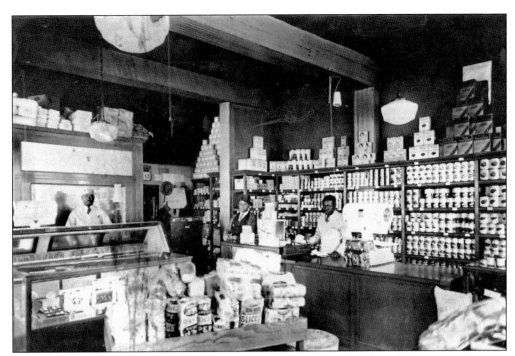

GENE BESS LACY GROCERY STORE. Gene Bess Lacy Grocery Store, located on Greenup and Robbins Streets in Covington, provided much-needed food items, important conversations, and a sense of community for the city's African-American residents. Most of the time, this facility was populated with many residents of all ages. (Courtesy of the Kenton County Public Library.)

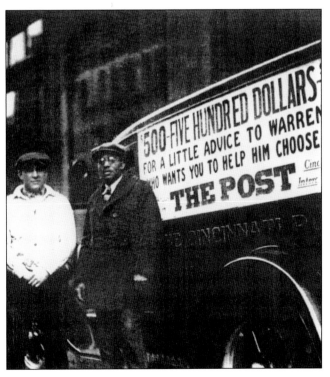

NEWSPAPERS ARE SOLD HERE. Sometimes the overwhelming demand for a particular product eliminated racial barriers and fostered a sense of understanding and reflection for many Northern Kentuckians. Pictured are two men, one African American and one white, preparing sell copies of the *Kentucky Post*. (Courtesy of Joyce Ravenscraft.)

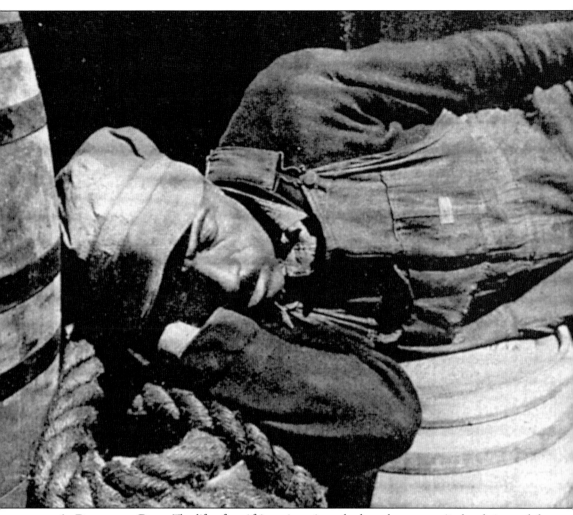

AT REST ON THE DOCK. The life of an African-American dockworker was quite hard. A usual day of work lasted from sunrise to nightfall. Sometimes workers would also be called to night duty. However, some black laborers did break to rest their tired minds, bodies, and souls. (Courtesy of Virginia Bennett.)

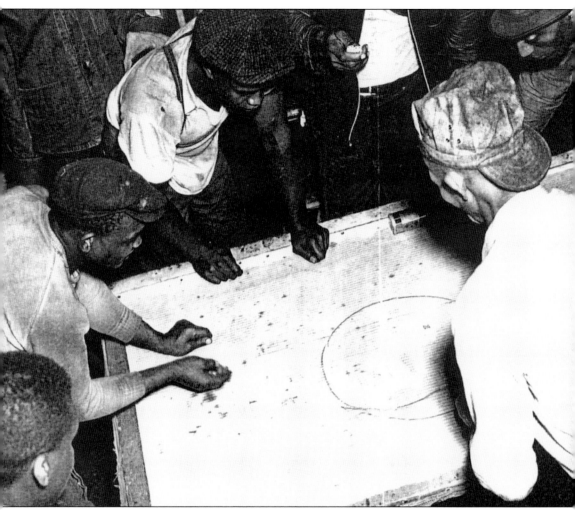

Fun and Games. Shown are several African American dock workers involved in a dice game. Such activities enabled many laborers to enjoy the company, pleasure, and solidarity of their co-workers without the pressures of their job. (Courtesy of Virginia Bennett.)

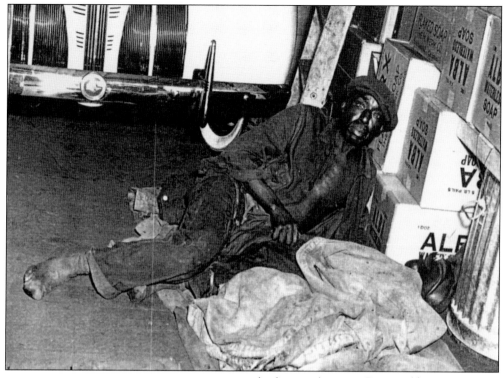

AN AFRICAN-AMERICAN LABORER TAKES A BREAK. At times, the hard life of African-American Northern Kentuckians was so intense that some dockworkers had to find rest in unusual places. Here, a laborer discovered a sleep haven among some soap boxes. (Courtesy of Virginia Bennett.)

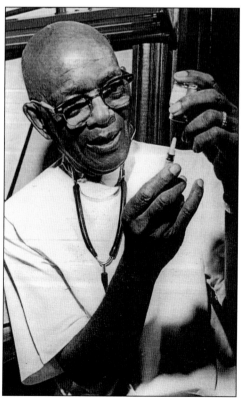

DR. JAMES E. RANDOLPH. Born in 1888, Dr. Randolph attended Lincoln University and Meharry College Medical School. In 1922, he moved to Covington and opened his practice at 1039 Greenup Street. From 1922 to 1958, a majority of the city's babies were delivered by Dr. Randolph. Along with receiving many awards in recognition of his community service and activism, Dr. Randolph had a park named in his honor in 1975. (Courtesy of the Kenton County Public Library.)

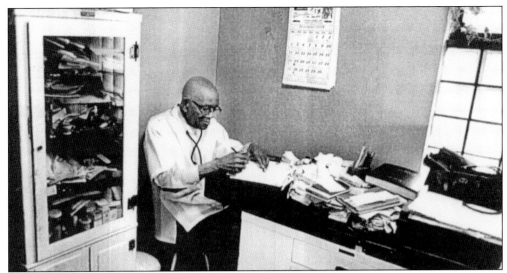

DR. RANDOLPH AT WORK. This photograph shows Dr. Randolph at work in his office on Greenup Street. He constantly and dedicatedly served as a general physician until his death on May 23, 1981, at the age of 93. (Courtesy of the Kenton County Public Library.)

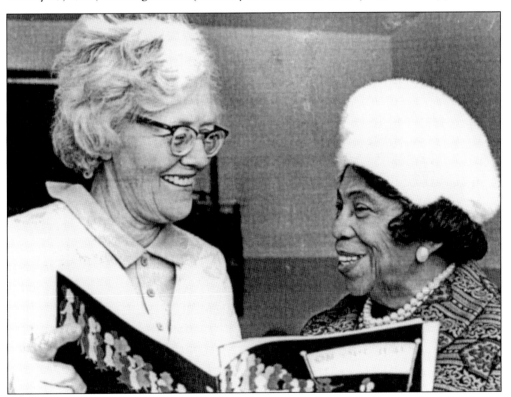

MRS. LORETTA RANDOLPH. This *Kentucky Post* photograph shows Mrs. Loretta Randolph in the company of Mrs. O. Worth May in 1973. Such a public appearance was not a usual occurrence for Mrs. Randolph because she was a very private person. (Courtesy of the Kenton County Public Library.)

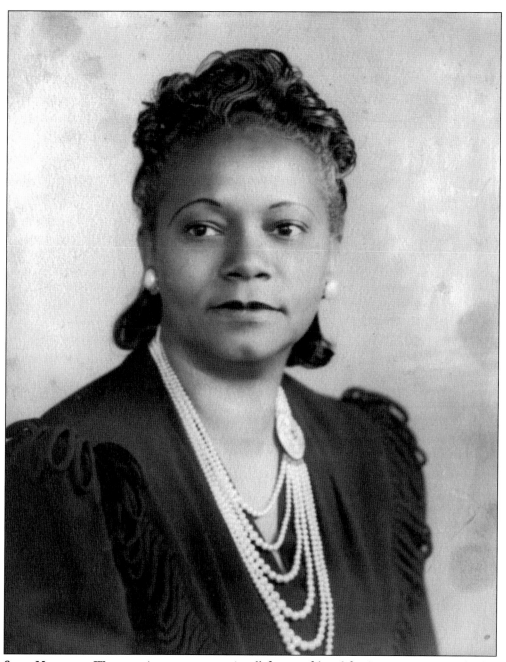

SUSIE MASTERSON WHATLEY. A great success in all facets of her life, Susie Materson Whatley was a very important resident of Covington. Some of her most important achievements were being the wife of General Whatley and mother of Preston Lee Smith. (Courtesy of Mary Northington.)

ENJOYING A RIDE. This photograph shows that, on occasion, community building crossed the racial divide. A member of the First Methodist Day-Care Service moves an integrated group of children through the streets of Covington. (Courtesy of the Kenton County Public Library.)

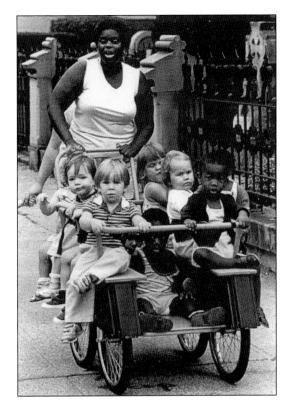

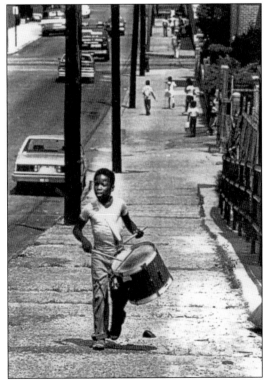

CHRIS THOMPSON. Pictured is Chris Thompson, a sixth-grade student at John G. Carlisle School, in Covington, walking down the street, playing his drums for all to see in 1982. Such a performance usually generated praise from many bystanders and neighbors. (Courtesy of the Kenton County Public Library.)

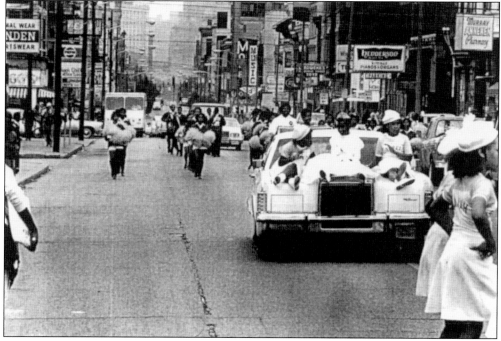

MADISON STREET PARADE. This 1983 photograph from the *Kentucky Post* shows the festive nature of an annual parade that turned down Madison Street and 10th Avenue in Covington. Shown here are several high school marching bands and a few groups of cheerleaders. (Courtesy of the Kenton County Public Library.)

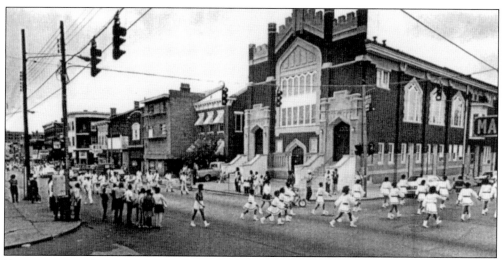

THE ELKS DRILL TEAM. Turning down Robbins Street to Madison Street, the Elks Drill Team, according to most accounts, performed magnificently. For many days, the impact of this type of celebration energized the black American community of Covington. (Courtesy of the Kenton County Public Library.)

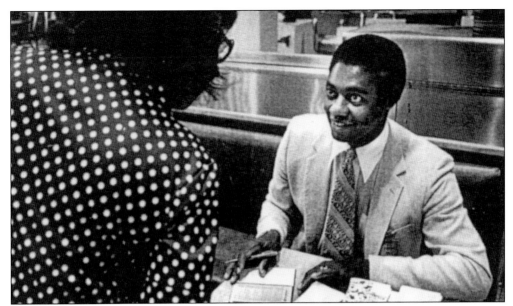

Oscar Robertson. Born in 1938 in a segregated public housing project in Indianapolis, Indiana, Oscar Robertson quickly made a name for himself on the basketball course in his hometown and later at the University of Cincinnati and in the National Basketball Association (NBA). He is shown working at the Internal Revenue Service (IRS) in Covington in 1981. (Courtesy of the Kenton County Public Library.)

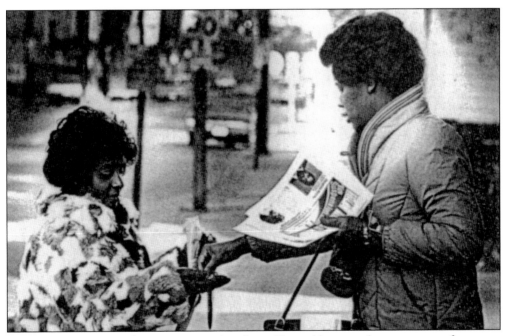

Handing Out Flyers. African-American Northern Kentuckians used a vast array of avenues to build and fortify their communities. Pictured is Pat Fann, a local resident of Covington, handing out a flyer to someone about an important community event. (Courtesy of the Kenton County Public Library.)

A Portrait. This longstanding Covington resident appears to be dressed for a formal engagement with friends or various family members. His distinguished view seeks to reveal a sense of prestige or importance. (Courtesy of Mary Northington.)

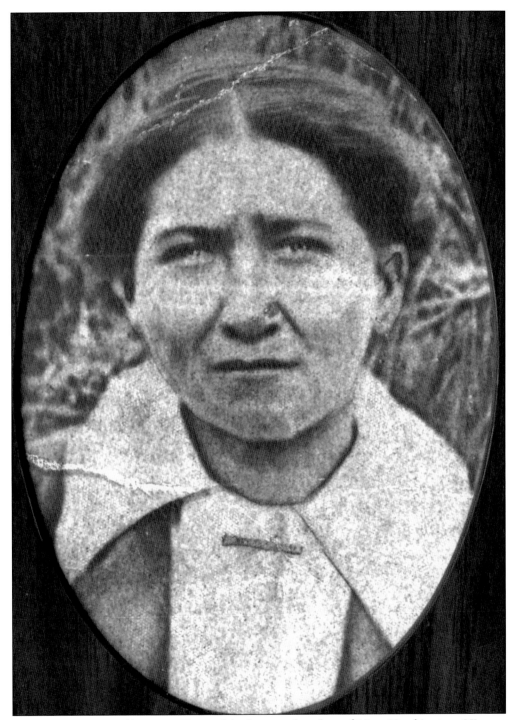

AN AFRICAN-AMERICAN TREASURE. Pictured is the grandmother of Mary Northington, Minerva Whatley. As a biracial child of African and Native American descent from Alabama, Minerva and her family moved to Covington during the early 1900s and became a respected member of the community over time. (Courtesy of Mary Northington.)

AN EXCITED CHILD. Seated here is a Covington child named Sam. It appears that he is very excited about having his picture taken by a professional photographer from a Cincinnati company. (Courtesy of Mary Northington.)

Seven

FAMILY LIFE

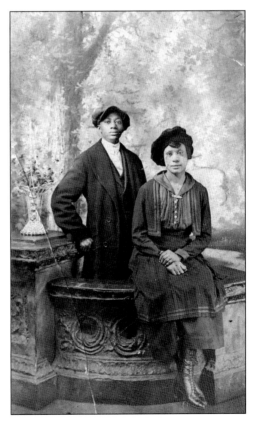

READY FOR AN OUTING. Partly in response to the intense racial tensions that emerged when World War I ended, during the 1920s, African Americans began to articulate a more nationalist, militant, and artistic voice for racial equality and social justice. This message also moved into the fashion world with a new style of dress, illustrated by this photograph of a local African-American couple. (Courtesy of Mary Northington.)

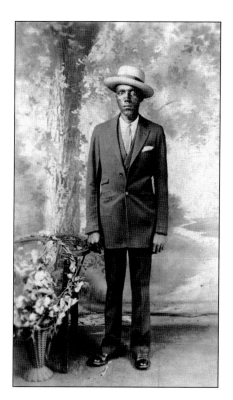

GOING OUT ON THE TOWN. This African-American Northern Kentuckian is dressed in the fashion of the day during the 1930s or 1940s. However, his outfit represents clothing that most black American men wore only on special occasions. (Courtesy of Mary Northington.)

AN AFRICAN-AMERICAN CHILD. Throughout the decades, hundreds of black American children lived, played, and were educated in Northern Kentucky. They ranged in age from infant to pre-teenagers. This photograph shows one youngster with his stuffed animal. (Courtesy of Mary Northington.)

THE INNOCENCE OF A CHILD. This black American toddler seems to be enjoying herself in anticipation of having her picture taken by a photographer. The tactics that were used to motivate this child to reach this stage of interest are unknown. (Courtesy of Mary Northington.)

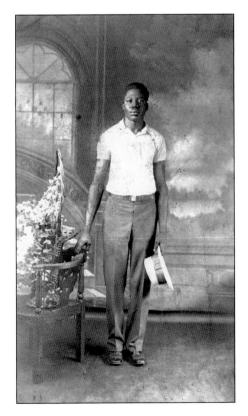

READY FOR SUMMER. Pictured here is an African-American Northern Kentuckian who is dressed for a summer day, full of adventure and excitement. His clothing is typical of outfits that many black Americans wore during the 1920s or 1930s. (Courtesy of Mary Northington.)

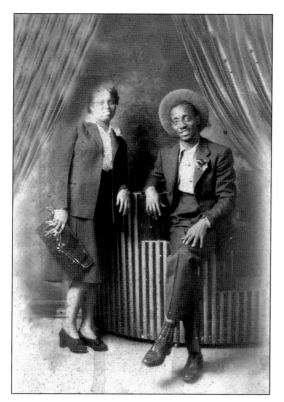

FORMAL ATTIRE. This photograph shows the classic wardrobe that African-American Northern Kentuckians wore during the 1920s or 1930s. The woman has on a two-piece outfit, with a matching purse, while the gentleman sports a two-piece coat and pants set. (Courtesy of Mary Northington.)

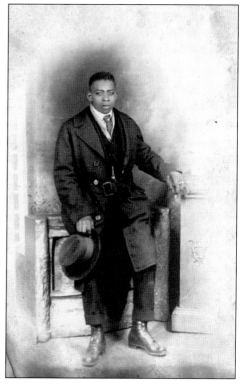

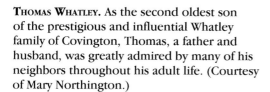

THOMAS WHATLEY. As the second oldest son of the prestigious and influential Whatley family of Covington, Thomas, a father and husband, was greatly admired by many of his neighbors throughout his adult life. (Courtesy of Mary Northington.)

WILLIAM WHATLEY. A longtime resident and community stalwart of Covington, William worked on the local railroad in Cincinnati, Ohio, for many years. He also served in the military during World War II. (Courtesy of Mary Northington.)

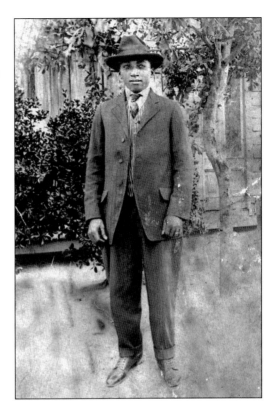

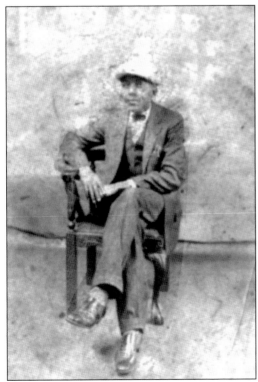

IVERY WHATLEY. Ivery Whatley was born in 1904, one of several brothers of the Whatley family of Covington. Ivery participated in numerous community events and church activities that brought him and his community much prestige and joy. (Courtesy of Mary Northington.)

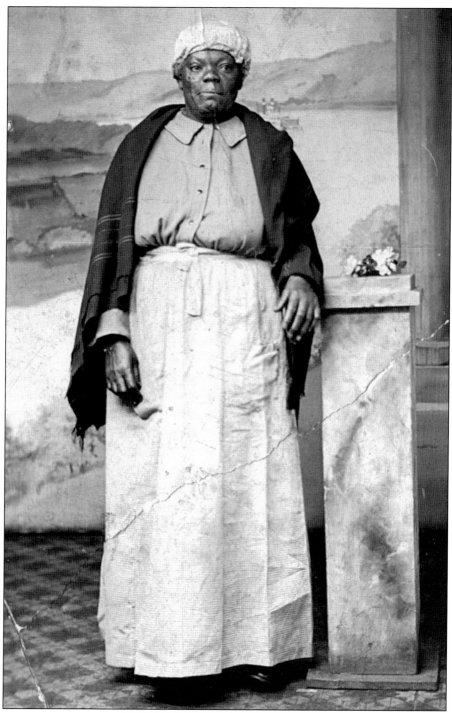

AN AFRICAN-AMERICAN WOMAN AND DOMESTIC WORK. Probably since the Civil War, African-American women have performed as domestic workers for white families. This activity usually intensified during war years. Even in Northern Kentucky, this occupation was populated by black American women. (Courtesy of Mary Northington.)

WILLIAM WHATLEY. William Whatley was a very important community activist during the 1930s and 1940s. He is shown here in attire that illustrates that fall weather is upon the residents of Covington. (Courtesy of Mary Northington.)

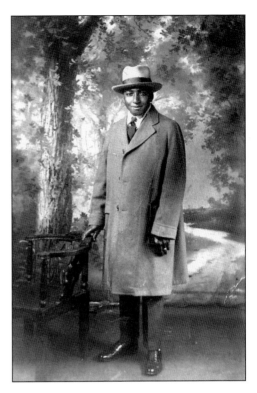

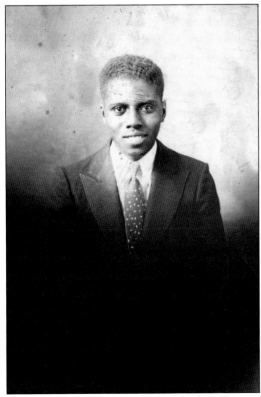

WALTER WHATLEY. Born in 1914, in Lowndes County, Alabama, Walter Whatley moved to Covington at the age of seven, where he lived with his grandparents until his teenage years. He attended Seventh Street Colored School and Lincoln Grant in Covington, as well as Withrow High School in Cincinnati. Whatley also served in the U.S. Air Force as a sergeant of operations during World War II. (Courtesy of Mary Northington.)

107

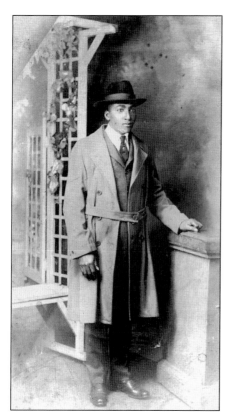

WILLIAM WHATLEY. As an important member of the Whatley family, William Whatley participated in numerous family events and social engagements. He also took part in several community functions that sought to enhance the lives of Covington's African-American residents. (Courtesy of Mary Northington.)

SCHOOL DAYS. Some African-American students viewed education as formal training or an occupation that required the appropriate clothing. This photograph shows a picture of one such pupil during the early 1950s. (Courtesy of Mary Northington.)

A MINISTER AND HIS FAMILY. In 1943, Rev. Andrew White became the 27th pastor of the St. James AME Church, located on 120 Lynn Street in Covington. Several years later, in 1945, the church celebrated its 75th anniversary. Pictured here is Reverend White and his family enjoying the event. (Courtesy of the Northern Kentucky African American Task Force, Frank W. Steely Library. Northern Kentucky University.)

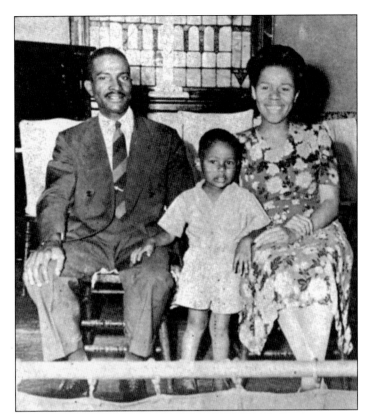

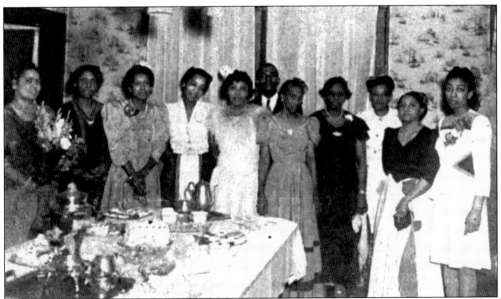

A PARTY. Pictured in the photograph are Sadie L. Dunham (far left, holding flowers) and some of her close friends at a celebration. This event occurred soon after the church service at St. James AME had ended for the day. (Courtesy of the Northern Kentucky African American Task Force, Frank W. Steely Library.)

109

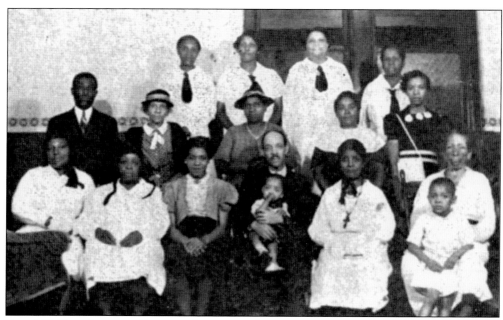

REV. A.H. TATE. Rev. A.H. Tate was the pastor of St. James AME from 1936 to 1939. Under his tutelage, the congregation of the church increased greatly. This photograph shows Reverend Tate and a group of stewardesses. (Courtesy of the Northern Kentucky African American Task Force, Frank W. Steely Library, Northern Kentucky University.)

DAVID WHATLEY. For many years, David Whatley lived on Linn Street, across from the Jacob Price Homes. (Courtesy of Mary Northington.)

TWO BROTHERS AND A SISTER. From left to right are Jacob and Claude Matthews (standing) and Mrs. Velma Golby (seated). All three individuals regularly attended St. James AME Church. (Courtesy of the Northern Kentucky African American Task Force, Frank W. Steely Library, Northern Kentucky University.)

WILLIS LEON WHATLEY SR. Born on July 19, 1921, Wills Leon Whatley Sr. grew up and attended several schools in Covington. He was baptized at a young age by Rev. William Taylor. In 1976, Whatley retired from Covington's Department of Public Works. (Courtesy of Mary Northington.)

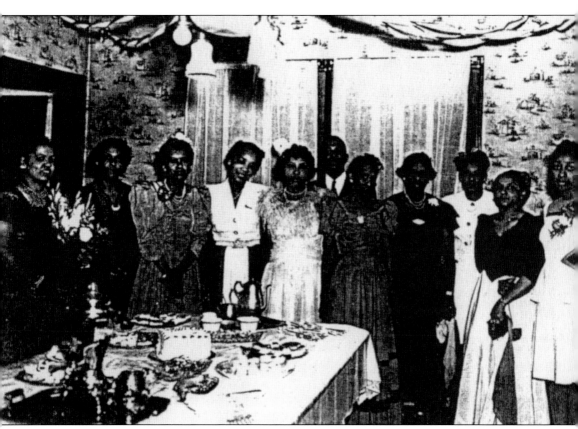

A Bride and Her Close Friends. Many African-American women established lasting friendships as a wedding was being planned. This type of relationship constantly shaped the lives of many residents several decades after the event itself. Pictured here is a group of black women at a celebration just before the marriage ceremony. (Courtesy of the Northern Kentucky African American Heritage Task Force, Frank W. Steely Library, Northern Kentucky University.)

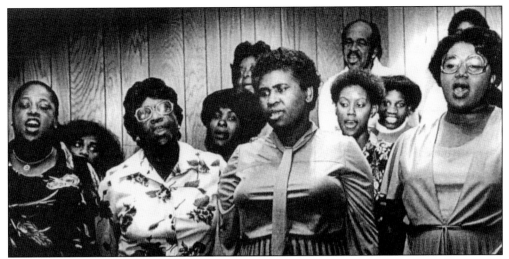

A Church Choir. Pictured are several members of the Macedonian Missionary Baptist Church Mass Choir. Identified from left to right are (front row) Jeanette Watts, Louise Harrison, Carolyn Watkins, and Mary Dees. (Courtesy of the Kenton County Public Library.)

Sam Whatley and Joy. These two Covington residents are shown spending the day at a local automobile dealer. This pair is in the process of buying a car. (Courtesy of Mary Northington.)

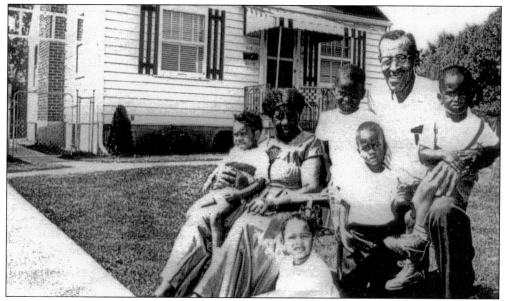

THE BOOKER FAMILY. During the 1960s, the population of African-American residents gradually increased. Perhaps this trend occurred in part because of the availability of relatively inexpensive land or relatively mild racial atmospheres that had gradually developed through the region. For example, the Booker family (pictured here) lived in Elmsere during this era. (Courtesy of the Kenton County Public Library.)

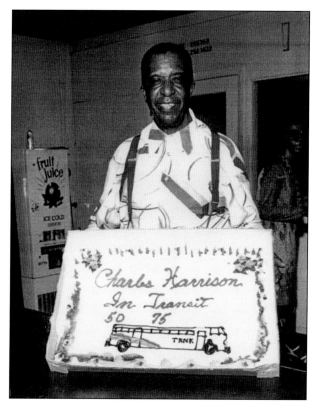

CHARLES HARRISON. During the early 20th century, Covington's expansion intensified with the incorporation of Central Covington and West Covington in 1906 and 1916 respectively. This trend continued from the Great Depression to the 1970s. The later period also witnessed the creation of economic opportunities for many African-American Northern Kentuckians. One example is bus driver Charles Harrison, shown here holding a cake. (Courtesy of the Kenton County Public Library.)

Eight

THE WAR YEARS

A LOCAL AFRICAN-AMERICAN SAILOR. During World War II, thousands of black Americans served in the armed forces. These men and women came from various backgrounds and cities. Pictured here is an African-American sailor who lived in Covington. (Courtesy of Mary Northington.)

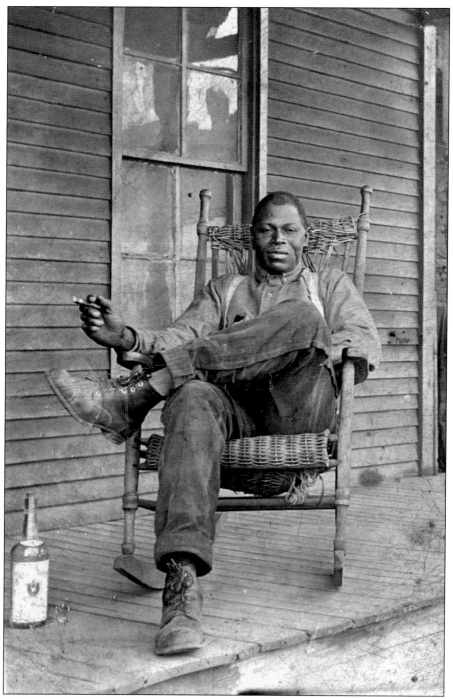

GENERAL WHATLEY. In April 1917, African Americans were among the first to volunteer to serve in the armed forces. Numerous issues motivated them to sacrifice the relative comforts of home for military life. This Covington resident, who lived on 15 East 9th Street, known as John "General" Whatley (although his actual rank in the military is unknown), served for several years during the war. (Courtesy of Mary Northington.)

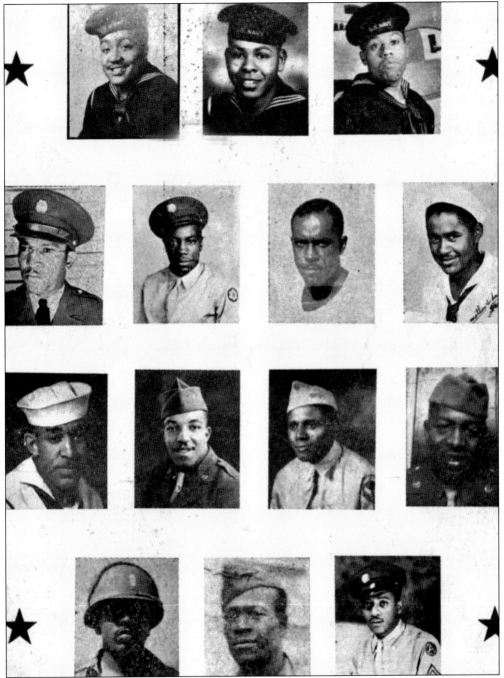

AFRICAN-AMERICAN SERVICEMEN. From left to right are (first row) Vernon Brown, William Orr, and Lee Smith; (second row) Thomas Givens, William Brown, Sanders Streams, and Irvin Garrett; (third row) William George Sr., Charles Stewart, Walter Whatley, and Henry Brown; (fourth row) Melvin Walker, an unknown soldier, and James Rucker. (Courtesy of the Northern Kentucky African American Heritage Task Force, Frank W. Steely Library, Northern Kentucky University.)

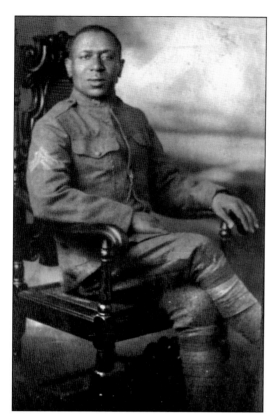

AN AFRICAN-AMERICAN WAR VETERAN. During World War I, almost every black American soldier had to deal with institutional racism and various outward acts of racial discrimination. Hostility from white soldiers and civilians also made it very difficult for African-American servicemen to remain enthusiastic about fighting for their country. Despite these issues, black American soldiers performed their duties with pride, skill, and precision. Pictured in uniform here is John "General" Whatley. (Courtesy of Mary Northington.)

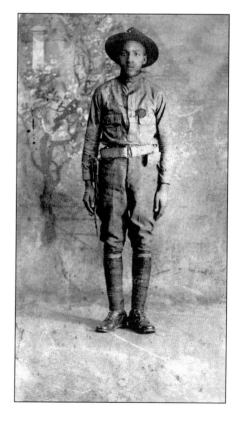

JOE WHATLEY. As did several members of his family, Joe Whatley served in the armed forces. His distinguished service in the military during World War I brought much pride and honor to not only his family but the entire African-American community of Covington. (Courtesy of Mary Northington.)

Nine

FIGHTING
FOR FREEDOM

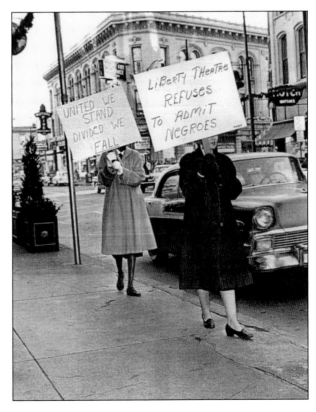

SEGREGATION AND THE LIBERTY THEATER. As part of the larger black freedom struggle to end racial segregation and discrimination throughout the nation, several local Congress of Racial Equality (CORE) volunteers demonstrated outside the Liberty Theater in December 1960. (Courtesy of the Kenton County Public Library.)

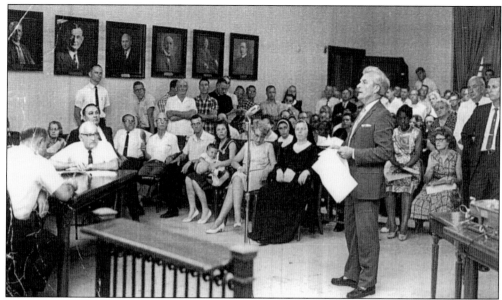

A Heated Open Housing Meeting. In Covington in 1967, a public meeting was held to discuss a citywide Open Housing Ordinance. Soon, a heated debate emerged, and again the problem of racial discrimination that the city had failed to deal with throughout the 1960s came to the surface. (Courtesy of the Kenton County Public Library.)

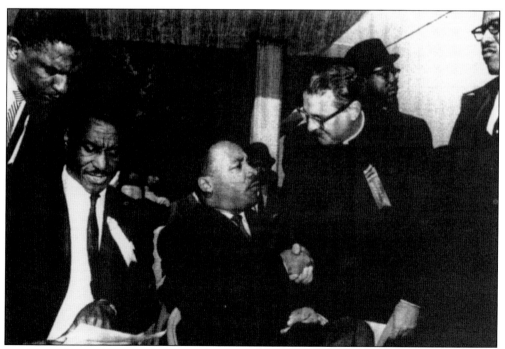

Dr. Martin Luther King Jr. Dr. King often traveled to Kentucky to visit his brother, A.D., who was a minister at a church in Louisville. He is pictured here in an important conversation with Rev. Fred Shuttlesworth, a resident of Cincinnati, Ohio, and several other community activists and local leaders. (Courtesy of Joyce Ravenscraft.)

CHILDREN AND DR. MARTIN LUTHER KING JR. During the mid-1960s, Dr. Martin Luther King Jr., Andrew Young, Rev. James Bevel, Rev. C.T. Vivian, and many other civil rights activists decided it was time to use African-American children in the black freedom movement. This photograph shows that the legacy of this effect continued with a Dr. King celebration, led by children, during the 1980s in Covington. (Courtesy of the Kenton County Public Library.)

IN MEMORY OF DR. MARTIN LUTHER KING JR. The legacy of Dr. King continues to inspire adults and children throughout the United States and the world. Numerous celebrations are held in January to highlight the ideas and impact of such a powerful human being. His spirit burns in most people like an entire flame. Picture is this image constructed by several Covington middle school students. (Courtesy of the Kenton County Public Library.)

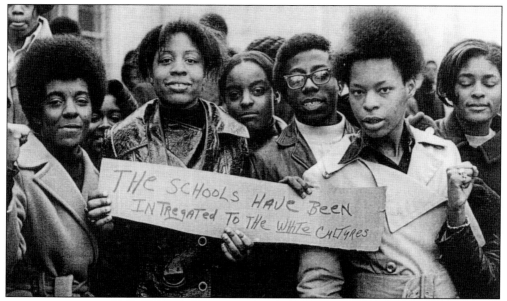

A Student Protest. In 1970, a group of student at Holmes High School held a demonstration to protest the lack of African-American history and culture courses offered at their institution. On one level, this intense rally reflected the transformation of the broader civil rights movement into its militant and "Black Power" phase. (Courtesy of the Kenton County Public Library.)

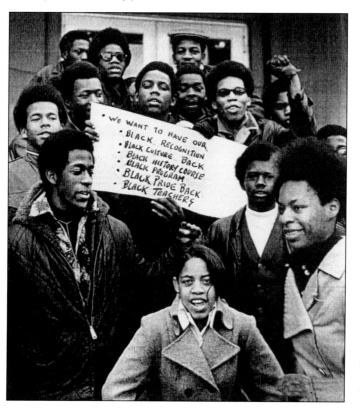

A Demonstration for Quality Public Education. During the early 1970s, the student movement at Holmes High School reached the Covington Board of Education. Pictured are several protesters voicing their opinion about the lack of African-American teachers as well as programs and course offerings. (Courtesy of the Kenton County Public Library.)

JIM SIMPSON. As one of the first African-American government officials in Covington, Jim Simpson tied to address and deal with some of the major problems that had affected the local black American community for several decades. This photograph shows him standing next to Mayor Bernie Grimm. (Courtesy of the Kenton County Public Library.)

THE OATH OF OFFICE. This photograph shows Jim Simpson, who was probably one of the first African-American city council members, being sworn in in 1973. Simpson served in this position for several years. (Courtesy of the Kenton County Public Library.)

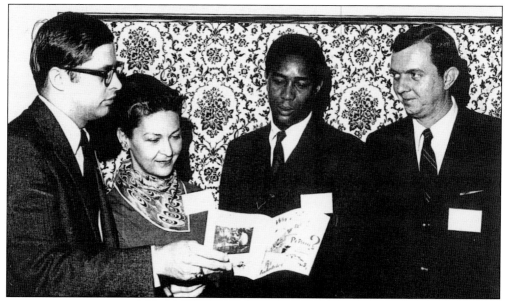

COVINGTON MODEL CITIES. During the 1960s and 1970s, several programs were established to assist various struggling sections of Covington. This photograph shows members of the Covington Model Cities at a 1969 Kentucky Model Cities Seminar. From left to right are William Kingsbury, Ruth Hedrick, Dave Johnson, and Jim Clay. (Courtesy of the Kenton County Public School.)

MRS. MARY NORTHINGTON. As a co-founder of the Northern Kentucky African American Heritage Task Force (NKAAHTF), established in 1995, Mary Northington, pictured at left, continues to be a powerful civic leader and community activist who advocates for the welfare of young people, the preservation of African-American history, and the promotion of quality education throughout Northern Kentucky. She is shown in front of a displayed that honors her late mother, Jane Roberta (Whatley) Summers. (Courtesy of Mary Northington.)

AN AWARD CEREMONY. As a community activist in Northern Kentucky, Jane Roberta (Whatley) Summers received numerous awards and honors from individuals, the larger community, the region, and the Bluegrass State itself. Pictured is Mrs. Summers at one of these events during the late 1980s. (Courtesy of Mary Northington.)

JANE ROBERTA (WHATLEY) SUMMERS. Jane Roberta (Whatley) Summers moved to Covington in 1934. As a resident and community activist, she constantly fought for racial equality and social justice for all citizens. As the first African-American female manager of the Jacob Price Homes, where she served for 25 years, Mrs. Summers started numerous outreach programs to help her neighbors and friends. (Courtesy of Mary Northington and Marilyn Smith.)

SELECTED BIBLIOGRAPHY

NEWSPAPERS

The Cincinnati Enquirer
The Covington Journal
The Daily Commonwealth
The Kentucky Enquirer
The Kentucky Post
The Licking Valley Register

BOOKS

Aron, Stephen. *How the West was Lost: The Transformation of Kentucky from Daniel Boone to Henry Clay*. Baltimore: The Johns Hopkins University Press, 1996.

Clark, Thomas D. *A History of Kentucky*. Ashland: Jesse Stuart Foundation, 1980 (first published in 1937).

Friend, Craig T. *The Buzzel About Kentucky: Settling the Promised Land*. Lexington: The University of Kentucky Press, 1999.

Dunnigan, Allison A. *The Fascinating Story of Black Kentuckians: Their Heritage and Traditions*. Washington, D.C.: Association for the Study of Afro-American Life and History, 1982.

Griffler, Keith P. *Frontline of Freedom: African Americans and the Forging of the Underground Railroad in the Ohio Valley*. Lexington: The University of Kentucky Press, 2004.

Hardin, John A. *Fifty Years of Segregation: Black Higher Education in Kentucky, 1904–1954*. Lexington: The University of Kentucky Press, 1997.

Harrison, Lowell H. and James C. Klotter, eds. *New History of Kentucky*. Lexington: The University of Kentucky Press, 1997.

Howard, Victor B. *Black Liberation in Kentucky: Emancipation and Freedom, 1862–1864*. Lexington: The University of Kentucky Press, 1983.

Hudson, J. Blaine. *Fugitive Slaves and the Underground Railroad in the Kentucky Borderland*. Jefferson: McFarland and Company, 2002.

Kentucky Commission on Human Rights. *Kentucky's Black Heritage: The Role of the Black People in the History of Kentucky from Pioneer Days to the Present*. Frankfort: Kentucky Commission on Human Rights, 1971.

Kleber, John E., ed. *The Kentucky Encyclopedia*. Lexington: The University of Kentucky Press, 1992.

Klotter, James C. *Our Kentucky: A Study of the Bluegrass State*. Lexington: The University of Kentucky Press, 1992.

Long, John H. *Kentucky: Atlas of Historical County Boundaries*. New York: Simon and Schuster, 1995.

Lucas, Marion B. *A History of Blacks in Kentucky: From Slavery to Segregation, 1760–1891, Volume 1*. Frankfort: The Kentucky Historical Society, 1992.

McVey, Frank L. *The Gates Open Slowly: A History of Education in Kentucky*. Lexington: The University of Kentucky Press, 1949.

Nordheim, Betty Lee. *Echoes of the Past: A History of the Covington Public School System*. Covington: Covington Independent Public Schools, 2002.

Poston, Ted. *The Dark Side of Hopkinsville*. Athens: The University of Georgia Press, 1991.

Runyon, Randolph P. *Delia Webster and the Underground Railroad*. Lexington: The University of Kentucky Press, 1996.

Sears, Richard D. *Camp Nelson, Kentucky*. Lexington: The University of Kentucky Press, 2002.

Strangis, Joel. *Lewis Hayden and the War against Slavery*. New Haven: Linnet Books, 1999.

Trotter, Joe W. *River Jordan: African American Urban Life in the Ohio Valley*. Lexington: The University of Kentucky Press, 1998.

Walker, Juliet E.K. *Free Frank: A Black Pioneer on the Antebellum Frontier*. Lexington: The University of Kentucky Press, 1983.

Wright, George C. *A History of Blacks in Kentucky: In Pursuit of Equality, 1890–1980, Volume 2*. Frankfort: The Kentucky Historical Society, 1992.

ARTICLES AND OTHER SOURCES

Hargraves, William F. "A Comparative Study of the Educational Effectiveness of the White and Negro Schools of Covington, Kentucky." M.A. thesis, Miami University, 1935.

Hudson, J. Blaine. "Crossing the Dark Line: Fugitive Slaves and the Underground Railroad in Louisville and North Central Kentucky." *The Filson History Quarterly* 75 (Winter 2001): 33–83.

Meals, Claude. "The Struggle of the Negro Citizenship in Kentucky since 1865." M.A. thesis, Howard University, 1940.

Middleton, Stephen. "We Must Not Fail: Horace Sudduth, Queen City Entrepreneur," *Queen City Heritage* 49 (1991): 3–20.

Post, Edward M. "Kentucky Law Concerning Emancipation and Freedom of Slaver." *The Filson History Quarterly* 59 (1985): 344–367.

Raphel, Alan. "Health and Social Welfare of Kentucky People." *Societas: A Review of Social History* 2 (1972): 143–578.

Walker, Juliet E.K. "The Legal Status of Free Blacks in Early Kentucky, 1792–1825," *The Filson History Quarterly* 57 (1983): 382–395.

Wright, George C. "The End for Me, But a Beginning for Others: My Years of Research on Kentucky Blacks." *Register of the Kentucky Historical Society* (1991): 338–361.

SOURCES OF PHOTOGRAPHS
AND IMAGES

Behringer-Crawford Museum
Boone County Historical Society
Cincinnati Historical Society
Cincinnati Public Library, the Greater Cincinnati Memory Project
Erlanger Historical Society
Kenton County Public Library
The Kentucky Post
Northern Kentucky African American Heritage Task Force
Northern Kentucky University, Frank W. Steely Library
Northern Kentucky University, Institute for Freedom Studies